10

INDIAN

ART
MYSTERIES

THAT HAVE NEVER
BEEN SOLVED

MAMTA NAINY

Read more in the 10s series

10 Indian Animals You May Never Again See in the Wild
by Ranjit Lal
10 Indian Monarchs Whose Amazing Stories You May Not Know by Devika Rangachari
10 Indian Women Who Were the First to Do What They Did
by Shruthi Rao
10 Indian Champions Who Are Fighting to Save the Planet
by Bijal Vachharajani and Radha Rangarajan
10 Indian Heroes Who Help People Live with Dignity
by Somak Ghoshal

10 INDIAN ART MYSTERIES THAT HAVE NEVER BEEN SOLVED

MAMTA NAINY

duckbill

An imprint of Penguin Random House

DUCKBILL BOOKS

USA | Canada | UK | Ireland | Australia
New Zealand | India | South Africa | China

Duckbill Books is part of the Penguin Random House group of companies
whose addresses can be found at global.penguinrandomhouse.com

Published by Penguin Random House India Pvt. Ltd
4th Floor, Capital Tower 1, MG Road,
Gurugram 122 002, Haryana, India

Penguin
Random House
India

First published in Duckbill Books by
Penguin Random House India 2022

Text copyright © Mamta Nainy 2022

This is a work of non-fiction. The views and opinions expressed in this book are the
author's own and the facts are as reported by her which have been verified to the
extent possible, and the publishers are not in any way liable for the same.

ISBN 9780143457145

Typeset in Sitka by DiTech Publishing Services Pvt. Ltd
Printed at Replika Press Pvt. Ltd, India

Also available as an ebook

www.penguin.co.in

MIX
Paper from
responsible sources
FSC® C016779

10

INTRODUCTION 1

WHAT DO THE RIDDLES OF BHIMBETKA HIDE? 3

WHAT DID THE BUDDHA LOOK LIKE? 15

WHO PAINTED THE AJANTA CAVES? 25

WHY WAS THE KAILASANATHA TEMPLE
BUILT TOP TO BOTTOM? 34

ARE PITHORA PAINTINGS ACTUALLY MAPS? 43

WHY ARE WOMEN ARTISTS MISSING IN
MUGHAL ART? 52

WHAT IS MYSTERY OF THE INDIAN YELLOW? 63

WHO WAS BANI THANI? 72

WHO WAS THE REAL MANAKU OF GULER? 80

WHO PULLED OFF THE BIGGEST ART HEIST? 89

INTRODUCTION 1

WHAT DO THE RIDDLES OF DHOLAVIRA HIDE? 3

WHAT DID THE BUDDHA LOOK LIKE? 15

WHO PAINTED THE AJANTA CAVES? 25

WHY WAS THE KAILASANATHA TEMPLE
BUILT NEXT TO DUNGEONS? 34

ARE PITHORA PAINTINGS ACTUALLY MAPS? 43

WHY ARE WOMEN ARTISTS MISSING IN
MUGHAL ART? 52

WHAT IS MYSTERY OF THE INDIAN YELLOW? 58

WHO WAS BANI THANI? 77

WHO WAS THE REAL MENAKA OF GUJRAT? 80

WHO PULLED OFF THE BIGGEST ART HEIST? 89

INTRODUCTION

Intriguing characters. Lost masterpieces. Buried secrets. Mega heists. Mysterious disappearances. If this sounds like a thriller, well, the history of Indian art is no less. It is teeming with weird and wonderful mysteries that have confounded art lovers, historians and experts for decades, even centuries.

In this book, we will delve into the shadowy depths of Indian art to consider ten of these far-out mysteries that have one thing in common—their solutions remain tantalizingly out of reach. Often, the only people who know the truth behind these mysteries have taken their secrets to the grave. But that's no reason to fret—for, one of the most wonderful things about these art mysteries is that they're open to interpretation. You can pore over the pieces of art that lie at the heart of these mysteries over and over again and discover if there's more than meets the eye.

The mind-bending mysteries in this book transpired across eras—from prehistory to the present—and so, as we walk through the dusty roads of history, we will also take a trip across the most incredible artistic periods, encounter the many ideas about art, and come face to face with some

important artists and their works. All these mysteries are rooted in history—which is why each chapter begins with setting the historical context of the mystery. However, when one describes a mystery, one needs to imagine how it must have panned out—so there are some elements I have imagined as well. But the main components of each mystery are based purely in historical facts and findings.

Solving these mysteries inevitably requires some degree of sleuthing, because they involve works of art that are as intriguingly beautiful as the stories they hold. They contain cryptic clues, hidden details and serious surprises that will sometimes wow you and, at other times, leave you completely stumped! You can play detective by sifting and sorting the clues, analysing evidence, tracking the twists and turns, and drawing your own conclusions. The more you learn about the great pieces of art and their creators, the more clues you uncover. Who knows, maybe you can help solve these art mysteries that the world has been puzzling over? Art historians will be more than happy to cross these off their lists. Each mystery in the book is followed by an art activity to turn you into a complete arty-pants!

So, art detectives, are you ready to investigate some perplexing puzzles of Indian art history?

WHAT DO THE RIDDLES OF BHIMBETKA HIDE?

Time period: 10,000 to 8000 BCE
Location: Madhya Pradesh

The year was 1957. The archaeologist Dr Vishnu Shridhar Wakankar was waiting at the Bhopal railway station for his train to Itarsi one summer afternoon. The station bell clanged and the passengers who had been hanging around on the platform began bustling about.

The whistle of the train shrieked as it pulled slowly into the station. When the train came to a stop, Dr Wakankar shuffled into the train. He sat down next to a window. Within minutes, the station guard walked up the platform and blew his whistle. The train jolted forward and began to move out of the station.

Dr Wakankar gazed outside the window as the city outskirts shapeshifted into scrubby countryside. After about an hour or so, the train rumbled through a series of low-forested hills that caught his attention. The rocky outcrops were jutting out in startlingly unusual shapes— as if hewn by a giant hammer!

There's something different about these rocks, Dr Wakankar's instincts as an archaeologist told him. But before he could do anything, the train moved on.

Acting purely on a hunch, he got down at the next station and made his way up to the hills. Once there, he took a deep breath and got down to work. He thoroughly examined the massive rocks that formed natural shelters from the sun, rain and wind. Then, he decided to look at the underside of each of these rock shelters.

The very first rock shelter Dr Wakankar entered stunned him, for it had faded paintings of stick-figure humans and recognizable animals. He did not know how long he stood and stared at the paintings. He couldn't believe his eyes: 'This location is archaeologically important not just from India's point of view, but from humanity's.'[1]

Dr Wakankar had found himself face to face with the earliest surviving traces of human existence in the Indian subcontinent—the greatest prehistoric art gallery that the world had no clue about!

Who made these prehistoric paintings that Dr Wakankar had found? When exactly were these created; why and how? Pull up a bearskin rug, sit in front of a crackling fire and read on to put together the pieces of a giant prehistoric jigsaw puzzle. (Nah, just kidding! A warm duvet and an LED light would work just fine!)

CAVE ART AROUND THE WORLD

Cave paintings can be found almost all over the world. One of the first set of cave paintings that were acknowledged as being from the Stone Age are in the Cave of Altamira in Spain. Created about

[1] Kamat, K.L. 'Meeting V.S. Wakankar: Accidental Interview with Wakankar'. Kamat's Potpourri, http://www.kamat.com/kalranga/people/pioneers/wakankar.htm. First published online 10 June 2002; last updated 19 February 2021.

14,000 years ago, there are hundreds of animal figures painted on the ceilings of this cave complex in an extremely modern style and filled with colours of varying intensity—quite unlike other cave paintings that are usually composed of sharp outlines.

Another set of caves that house the most beautiful paintings is in Lascaux in France. About 18,000 years old, these were discovered by accident in 1940 by four boys and their pet dog when they were hiking outside a small town in south-western France—an area filled with limestone caves. Suddenly, their dog scampered off and disappeared inside a cave. The boys followed the dog into the long cave and were greeted by prehistoric drawings of animals!

Many other parts of the world, too, have their share of well-known cave paintings, such as Serra da Capivara in Brazil, Magura in Bulgaria, Tadrart Acacus in Libya, Cueva de las Manos in Argentina and Kakadu in Australia.

In India, there are about 5000 prehistoric cave sites where you can witness the magic of cave art. These include Edakkal in Kerala, Piklihal and Tekkalkota in Karnataka, Lakhudiyar in Uttarakhand, Kupgallu in Telangana and, of course, Bhimbetka in Madhya Pradesh.

HOW OLD WERE THESE PAINTINGS?

What comes to your mind when you think of the word 'old'? Last year's history book? Your grandmother? The time before the internet?

Think a little earlier than that—how about 3,00,000 years ago? Yes, that's the time when the first humans made their appearance on the planet. However, only a tiny fraction of their existence on Earth has been documented

or written down. So, a lot about prehistory—or history before people could etch things down in mud or stone or papyrus—is a big mystery.

It's not all dark and unknown, as you may be imagining. The early humans were a brainy bunch—they left behind intriguing hints about their world and lives in the form of the beautiful paintings they created inside the caves they lived in. And, by studying these paintings, archaeologists try to extrapolate and deduce the history of what happened before humans could write things down—exactly as Dr Wakankar also did.

After having discovered the prehistoric paintings inside the caves, or rather rock shelters, Dr Wakankar carried out extensive excavations on the site for sixteen long years. (Rock shelters are different from caves since they are smaller openings at the base of a rock face.)

These rock shelters were in a place called Bhimbetka, forty-five kilometres south-east of Bhopal. The legend goes that Bhimbetka gets its name from Bhima, the second of the five Pandavas in the Mahabharata. In some versions of the epic poem, it is said that when the Pandavas were banished from their kingdom by their cousins, the Kauravas, Bhima spent his days of exile in these caves. The word 'Bhimbetka' is said to have been derived from 'Bhimbaithka', meaning the '*baithak* or the seat of Bhima'.

After years of hard work, Dr Wakankar found some 750 rock shelters scattered over ten kilometres, out of which 500 were adorned with the most beautiful paintings. Apart from the paintings, Dr Wakankar and his team also found hundreds of stone tools layered into the dirt floors of these caves. In age, these ranged from 1,00,000 years

to 3000 years—which means that people from the Palaeolithic Age (the early part of the Stone Age) to the Mesolithic Age (the middle part of the Stone Age) had made these rock shelters in Bhimbetka their home.

WHO WERE THE FIRST PAINTERS AND WHY DID THEY CREATE THESE PAINTINGS?

The who and why of the creation of these ancient wonders on the walls of caves is intriguing for many reasons.

For starters, no one is sure who created them or why. Like so many other things in human history, we do not know who was the first person to create art in caves. Maybe it happened thus . . .

A cavewoman—or a caveman, no one knows—was sitting in her cave that overlooked a beautiful river. It was an awe-inspiring spot with a glorious view. Cool winds caressed her face as she watched different animals drinking water from the river: horses, bison, deer and more. Suddenly, the sky became dark, and she saw giant grey clouds drifting over the valley. In her imagination, their ever-changing shapes resembled animals.

'Doesn't that cloud look like a huge bison?' she asked the caveman who was sitting close by.

'I only see a cloud,' the caveman replied, shaking his ragged head of hair.

The woman, inspired by what she'd seen, picked up a piece of reddish-brown stone and etched out a simple outline of the cloud on the wall of the cave. She added details to this outline, such as the massive head of the

wild prehistoric bison, the large ears, slightly parted muzzle and curved horns. And before she knew it, the image had flowed from her mind, through her fingers, to the wall—like magic!

The cavewoman looked at what she'd just created in great awe. 'Look at this!' she exulted, pointing the drawing out to the caveman.

'Hmmm . . . that does look like a bison!' the caveman grunted in appreciation as the cavewoman grinned wide at her great new creation.

Maybe that's how the invention of drawing came about, more than 30,000 years ago.

Is this story true? Well, who's to say?

For modern archaeologists, these prehistoric drawings offer no definitive clue to their original purpose. Initially, researchers believed that cave art was related to the act of hunting, since many of these paintings depicted hunting scenes. Some suggested that the early people believed that capturing an animal's likeness on a wall made it easier to kill the animal in the wild. The basic idea was that if you paint a picture of a creature, then you have the power over it. It was like a helpful magic formula—if one painted a boar or a bison being killed by a hunter, then the next day, the painting, like a dream, would come true.[2]

Many researchers now suspect that cave art had purposes other than hunting magic. It could have been

[2] The French archaeologists Henri Breuil (1877–1961) and Henri Begouen (1863–1956) developed the theory of sympathetic magic, assuming that the prehistoric humans created images in order to influence the result of their hunt. Breuil's 1912 paper, 'The Subdivisions of the Upper Paleolithic and Their Meaning', in particular, is very eloquent on this theory.

for some ritualistic purpose, a wall ornamentation, a way of telling stories or sharing myths, a depiction of hunting strategies, or simply, ancient doodles. Doodling is a very basic human instinct after all. (You could doodle a passing bison yourself. If you don't find a bison, then doodle a cat or a dog!)

The ability to create and communicate using symbols is one of the characteristics that separates humans from any other species. It connects us with people who lived before us in a unique way, so these ancient paintings are the closest we'll ever come to really know of our long-gone ancestors.

WHAT KIND OF ART SUPPLIES DID THE STONE AGE PEOPLE HAVE?

Throughout history, many colours—both natural and synthetic—have stimulated the human imagination. And one of the earliest uses of natural colours can be seen in these prehistoric caves.

These colours, or pigments, were made from grinding different minerals to powder. Prehistoric people only had a few minerals to use: red iron-rich rock (ochre), white chalk and black manganese. From these, they were able to create different powders, ranging from yellow to brown to black. These pigments were then mixed with liquids like water, animal fat, vegetable juices and egg white to form a paste. They sometimes even used human saliva (ew!) and blood (don't try this at home, or your painting will be an open invitation to vampires!) to create the liquid binders. The coloured paste was then transferred to a long, flat bone to act like an artist's palette. Today, even after so many years,

these primitive paints haven't peeled! Don't you wish you could find stuff like this at your local stationery shop?

The early artists used feathers, fur, twigs, animal hair, chewed sticks (just the way you chewed on the head of your pencil when you were small) and their fingers as paintbrushes. Sometimes they incised the outlines of pictures into cave walls with sharp stones or charcoal sticks. Just as an artist would do today, these may have been the rough sketches before the artists went on to draw on the wall. The artists outlined the animal first, scratching with bones and stones, or with charcoal or burnt sticks from the cooking fire. They then filled in the drawings with colour.

The cave painters sometimes even used the bumps, crevices and swellings on the uneven walls of the cave to accentuate the animal's contours—a bulge for a belly, a bump for a hump, an indentation for an eye—giving the animals a fuller, sculpted sort of a look. Amazingly clever, isn't it?

WHAT'S PAINTED IN BHIMBETKA?

Picture walking into a cave with paintings splattered on the walls, giving you insight into the lives of those who roamed the caverns you are standing in. The cave paintings of Bhimbetka have remained windows into our ancestors' way of living. They offer an awe-inspiring view of history, told entirely in pictures—exactly like in the comic books you read!

The favourite subject of the prehistoric people was animals. Boars, elephants, buffaloes, deer, bison, dogs, monkeys and many other animals appear in several of

the scenes depicted in the Bhimbetka caves, making these rock surfaces come alive with thousands of animal stories. There are as many as twenty-nine species drawn on the walls of these rock shelters!

Humans—both alone and in groups—can also be found in many of the paintings. Armed with bows and arrows, slings and spears, they are often depicted hunting animals. Usually drawn as stick figures, the hunters are shown wearing loincloth and ornaments such as necklaces, bangles and wristbands. Some sport elaborate headgear made of feathers and horns—which perhaps suggests that they were important people, maybe a priest or a tribe chief.

The non-hunting scenes depict communal or domestic activities, such as food-gathering, childbirth, funerals and burials; the use of musical instruments; and communal dancing. The dance scenes often depict a group, in circles or in rows, holding hands, dancing to some unknown, ancient rhythm. Did they dance to celebrate a good hunt? Was their dance accompanied by songs—the first songs that humans ever sang? What were the dance movements these early humans used to express themselves? We do not know—but what we do know is that these communal dance scenes indicate that the concept of 'society' had already emerged.

One of the most prominent paintings discovered in the Bhimbetka rock shelters is of two elephants, both with great tusks pointing upwards. A man rides the smaller of the two animals, carrying a spearlike weapon in his left hand. Was this man a hunter? Or a king?

There's also what has come to be called Zoo Rock in Bhimbetka, which is one of the oldest examples of cave art here. It is festooned with the paintings of nearly 200 animals, with sixteen different species roaming across the wall—from deer with majestic antlers to bulky buffaloes to beautiful peacocks to massive elephants. In between the animals are small sticklike human figures. And amid all these animals jostling for space, there is a mahout goading an elephant through this prehistoric zoo like a zookeeper!

A rock painting in Bhimbetka shows the skeletons of horses. Another one shows a cow with two baby calves inside it. From this, we can deduce that the ancient man knew about animal anatomy and how animals looked under their skin.

In one of the hunting scenes on the walls of Bhimbetka rock shelters, a bison is shown in pursuit of a hunter whose companions watch helplessly—here, the hunter is being hunted! One can imagine that this is the recording of a real episode.

Near the entrance to the rock shelters of Bhimbetka, is the famous Auditorium Rock. It is dotted with ten curious cup-shaped depressions called cupules, hammered out by ancient tools. These depressions are believed to have been done by the early humans for some ritualistic purpose. How early, you might ask. The answer is: as far back as 1,00,000 years, which makes them the oldest symbols of human creativity on Earth (roughly about twenty times older than the cities of Harappa or the pyramids of Giza)!

People from various eras used the rocks in Bhimbetka as their canvas and there are many layers of paintings one on top of the other. In some places, there are as many

as ten layers of paintings to be found on the walls, long protected by the rock overhang—each peeling off a secret in human evolution. It's interesting to note that the cave dwellers of later periods did not erase the works created by earlier artists; instead, they chose to draw over existing images to create an eternal canvas.

These rock paintings show the evolution of man from a nomadic hunter-gatherer to farmer, from the Mesolithic through to the medieval eras. Many of these later paintings show advanced weapons; men riding horses and elephants; and even royal processions with horsemen, drummers and musicians in tow. But when exactly did this transition happen, why and how, we cannot say with any certainty.

DOES THE RIDDLE OF ROCK ART REMAIN UNSOLVED?

To a large extent, yes. When we look at a drawing or a painting, we often try to figure out why was the image made and what it means. No one knows why ancient people began to draw and at what point our clever ancestors made the final leap to having fully modern minds with imaginations to create these paintings. Were they just playing, with a child's curiosity, the game of turning bits of pigment into a form? Or had they, long before we realized, found a way to make objects speak beyond time and space? How we wish we could climb into a time machine and set the dial to 3,00,000 years ago! But till that happens, we can just marvel at the beautiful fluid lines and shimmering patterns across the craggy slabs of solid rock canvasses of the first artists and the story of evolution that they hold.

BE AN ARTY-PANTS!

Cave paintings might look easy, but try drawing exactly the way the first painters did and you will realize how clever they were!

Take a large sheet of brown paper and crumple it into a small ball. Open up the ball—the creases in the paper would create a unique texture, like the wall of a cave. Stick your sheet under a table with tape. Put a blanket over the table to create a cave-like atmosphere. Now, light up your cave with a flashlight. Take a coloured chalk and draw the outlines of any animal.

Take some natural materials, such as leaves, clay, lamp soot, turmeric and indigo, and crush them in a bowl. Mix the pigment with some water. Lying on the floor, colour the surface of your paintings with a twig or your fingertips.

This is how cave painters would have worked. Not as easy as it looks, isn't it?

WHAT DID THE BUDDHA LOOK LIKE?

Time period: Second century BCE to twelfth century CE
Locations: Gandhara, north-western Pakistan
and Mathura, Uttar Pradesh

When we think of Gautama Buddha, an image pops into our heads—a tall, slender man with long earlobes, dressed in a flowing robe, and his curly hair tied in a topknot. Gautama Buddha has been the subject of many statues, sculptures and paintings the world over. But did he really look like the way he has been depicted for centuries?

HAVE YOU SEEN THIS MAN?

Very few people perhaps would have spent more time with Gautama Buddha than his ten disciples or students. They would have spent many long hours with the Buddha—walking with him from one place to the other, sharing meals with him, attending to him while he meditated, and listening to him teach.

Now suppose those ten students were raised from the dead and were shown the images of the Buddha that we're all familiar with. Would they be able to recognize the long-eared man in an off-shoulder robe with a bun on his head? Or would they look at the images in great bewilderment, wondering who this man is supposed to be?

Surprise, surprise—in all likelihood, their reaction would be the latter. They would have no idea who the man in the images is and would probably say that their teacher looked nothing like that. So where did this image of the Buddha that we all know come from?

HOW DID IT ALL BEGIN?

Let's go back to about 2600 years ago when a lonely monk wandered the dusty roads of northern and central India, seeking the answer to the big questions that humans of all races and regions have been pondering over for the longest time—why are we born, why do we die, what exactly is the purpose of life?

Siddhartha Gautama (c. 480 BCE–c. 400 BCE) was a prince who chose to give up all his material wealth to follow his spiritual curiosities. The story goes that when he was about twenty-nine, he first travelled outside of his palace and encountered an old man, a sick man and a corpse—his first introduction to the pain and suffering of the world. After this experience, Prince Siddhartha gave up his royal life and travelled around the country on foot to find the answer to the causes of human suffering. And after years of pursuing his quest, training his mind, learning to focus his energies (and not checking WhatsApp or Instagram every two seconds), Siddhartha Gautama formulated an answer to this eternal question—an answer that has been considered amongst the most convincing of all the answers people across the world have come up with. He became the Buddha, the Enlightened One, and imparted his teachings through the entire duration of his eighty-year-long life.

It is believed that during Gautam Buddha's lifetime and for six centuries after his death, no image of him was created.

Why, you ask. Of course, it couldn't have been the lack of skilled artists at that time or an accidental oversight because the artists were busy creating other things. Scholars have come up with two theories to explain this. The first one is that the Buddha didn't want his image or idol to be worshipped. He wanted people to only follow his teachings and so, no idol or image of him was created during his lifetime or for some time after that while this desire was remembered. The second theory is that the Buddha was a divine being and his early followers believed that divine beings should not be defined or limited by their physical forms. And so again, no idol or image of him was created. Which of these two theories is true? The truth, we guess, lies somewhere in between.

Here's the interesting part, though—during the early years of Buddhism, the Buddha wasn't depicted as a human but in symbols related to his life. These symbols represented Buddha's philosophy—just as a flag represents a country or a small circle with three arches symbolizes whether there's Wi-Fi on your phone or not. (That would be oversimplifying it, but the idea was essentially the same.)

The symbols that represented the Buddha, however, had all kinds of interesting variations—an empty throne to represent how the Buddha gave up his kingdom to follow his spiritual quest, a bodhi tree under which he gained enlightenment, a lion to represent the courage needed to pursue the spiritual path, a dharma wheel that represents the Buddha's teachings of non-violence and compassion,

and so on. (Quite imaginative, don't you think? Can you come up with five symbols that represent you?)

But how do *we* know that the Buddha was represented in symbols? From the many stone sculptures and other evidences that archaeologists have found from that time, of course. In the Mauryan period, during the reign of emperor Ashoka (c. 268–232 BCE), for instance, many monuments and stone sculptures were commissioned. Although these sculptures have images of lions, wheels and other such symbols, there are absolutely no images of the Buddha. Emperor Ashoka also built many stupas, or sacred mounds, that had the ashes and the bodily relics of the Buddha, such as his teeth, hair and nails, preserved in them. These stupas are adorned with visual stories— just like the illustrated books you read—that celebrate the life of the Buddha. But these, too, don't have the human representation of the Buddha.

One of these images can be seen in a carving from a railing from the Bharhut Stupa depicting a royal couple paying their respects to Gautama Buddha. In this carving, the Buddha is represented by a dharma wheel. Another one can be found on the beautifully sculpted gateway of the Sanchi Stupa, which depicts a rather large king, probably Ashoka himself, and his two queens praying to a bodhi tree.

HOW DID THE BUDDHA ENTER THE WORLD OF HUMANS?

The short answer to that is: the image of the Buddha finally broke forth into the world 600 years after

his death because someone's inspired (read: heavily influenced) artistic imagination set itself rolling on a beautiful day when he—or maybe she or they—was feeling particularly chuffed.

The long answer to that question, of course, is one of the most intriguing stories in the history of art—one that is tied up with the coming of a new dynasty in India that, unrestrained by the conventions of the past, was able to set the image of the Buddha free into the world of humans. The story begins in the first century CE when the sounds of hoofs ushered in a new dynasty to rule the land—the Kushan dynasty. An Indo-European tribe that had long roamed the Asian steppes, the Kushans settled in upper Afghanistan and then swiftly came to India to form an empire that straddled most of north India. With them came a new outlook to art—that of the depiction of human forms, both of kings and gods, in art.

The Kushan Empire thrived in the second century CE and extended over a vast area, including northern India, Kashmir, Pakistan, Afghanistan and Iran, under the reign of a king named Kanishka whose only sculpture in existence shows him as a nomadic warrior dressed in a long-belted coat, baggy pants and big boots. Under him, the Kushan kingdom reached great heights. It was right at the centre of the Silk Route and this strategic location helped the Kushans to control trade. They charged a significant fee to transport goods and soon became prosperous.

Kanishka had an eclectic interest in various religions, but became a great patron of Buddhism and contributed greatly to its spread throughout central Asia into China.

His religious policies, combined with artistic influences arriving from the western Graeco-Roman and Iranian cultures, resulted in the development of a new trend in art—of portraying the Buddha in a human form. It is on the coins issued during Kanishka's rule that we find the first images of the Buddha.

Two great schools of sculptural art were established during this period that developed naturalistic styles of representing the Buddha—one centred in Gandhara, a region that stretches across present-day Afghanistan and Pakistan, and the second centred in Mathura.

During Kanishka's time, Gandhara was a region buzzing with activity. It was not just at the heart of the Silk Road but also a bridge between the east and the west, where artists and craftsmen from all over central Asia, Bactria and India met. Kanishka invited a number of Graeco-Roman artists to work in his kingdom and commissioned them to make sculptures of the Buddha.

These artists had no idea of the Buddha's real appearance because there was nothing by way of references, so they developed their own images of the Buddha in a style they best knew and practised. They took the most notable characteristics of gods from the Graeco-Roman world, such as long, curly hair; athletic bodies; flowing garments that resemble the Roman toga; a halo behind the head that was originally a feature of classical Roman art, and combined these with a few of the thirty-two physical characteristics that, according to the Buddhist discourses, all great men should have. The long, sweeping arms; elongated earlobes; a dot on the forehead; and a topknot are some of these

characteristics. Lo and behold, the image of the Buddha was ready!

Another important artistic centre during the Kushan period was Mathura. But the images created in Mathura were quite different from those created in Gandhara. They were carved out of red sandstone, unlike Gandhara artists who used grey sandstone. The artists in Mathura followed the artistic style that was more Indian, modelled on the *yaksha* images that were very popular in Indian tradition. Yakshas were basically slightly plump divine beings who were considered the caretakers of treasures in the natural world. So, Mathura Buddhas have fuller bodies with a slight paunch, fuller lips and wider eyes. Their faces possess a deep sympathy and even a hint of a smile.

While commissioning these images, was Kanishka aware of doing something that had never been done before or was he just being a zealous patron of Buddhism? Was the depiction of the Buddha as a human actually influenced by Greek art or could there have been a lost origin story of the Buddha, which was then adapted by the Greek-trained craftsmen? No one knows for certain, so your guess is just as good or bad as ours!

OKAY, BUT WHAT DID THE REAL BUDDHA LOOK LIKE?

Was Gautama Buddha fair or dark? Was he tall or short? Was he muscular or lean? Did he have a beard or was he clean-shaven? Did he have long hair or short hair? No answers to these questions have been found so far.

Till about the first century BCE, the teachings of the Buddha were passed on orally—they were never written down. If things are not written down or recorded, historians can never be sure about them. So, much about the physical appearance of the Buddha is shrouded in mystery.

To muddle up the mystery even more, the earliest surviving written-down Buddhist texts do not give a whole lot of information about what Gautama Buddha looked like, but one thing they all seem to agree on is that he shaved his head when he first set out on his quest and that he remained bald throughout his life. This means the ancient sculptures of the Gautama Buddha are not accurate, since all of them show him with a head full of curly hair.

There are also multiple Buddhist texts with stories of people seeing the Gautama Buddha and not recognizing him as such because he looked quite like an ordinary monk. For instance, in the *Digha Nikaya*, a Buddhist scripture that dates back to first century BCE and consists of the long discourses or teachings of the Buddha, King Ajatashatru of Magadha goes to visit Gautama Buddha, but he can't tell him apart from the other monks and he is compelled to ask the personal physician of the Buddha, Jivaka, which of the monks is the Buddha.

Similarly, another story from *Majjhima Nikaya* (c. third century BCE–second century CE), a collection of discourses or teachings of the Buddha, says that once a beggar who was deeply impacted by the teachings of the Buddha went to meet him in person, but he couldn't recognize him as the Buddha.

This clearly shows that the images that we know of the Buddha are based on how he was imagined by people who lived many centuries after his death, and not on what he really looked like when he was alive.

WILL WE EVER FIND OUT?

Maybe. Maybe not. The Buddha is one of the best-known figures in history but, in many ways, he is also the least known.

It's strange how history sometimes works. An image or a story sets itself free from the cages of authenticity, moves into the world of imagination—journeying across languages, time and belief systems—and becomes a creature of its own. This is exactly what happened to the image of the Buddha. The imagination and ideas of various people at various times came together to form a recognizable image of the Buddha that spread along the trade routes and adjusted itself slightly to the places it travelled to.

The first images of the Buddha created during the Kushan period unlocked the essence of the Buddha in stone, which was further spread during the Gupta period in the fifth century and since then have been reproduced hundreds of millions of times in the form of paintings, sculptures and statues the world over. And each of these early images of the Buddha remain invaluable—just as the mysteries behind them remain enduring. The Buddha would have agreed, we believe.

BE AN ARTY-PANTS!

Here's an art game for two or more players. Player A chooses a famous person from history without revealing the name of this person to the other player/s. Player A then describes this person as precisely as possible. The other player/s use/s this description to draw or paint their own interpretations of this person. When finished, the players can compare the drawing with the actual photograph of this person.

WHO PAINTED THE AJANTA CAVES?

Time period: Second century BCE to seventh century CE
Location: Aurangabad, Maharashtra

It was a bright April morning in 1819. Captain John Smith, a young British cavalry officer, was on a hunting expedition in the thick jungles around Aurangabad in the Deccan region of present-day Maharashtra. He, along with his hunting troop, walked gingerly through the wilderness, keeping his wits sharp and eyes out for game.

Suddenly, the men heard the savage growl of a tiger that pierced through the quiet of the jungle. Captain Smith ordered the others to follow him towards a deep ravine from where the sound seemed to have come. He tracked the animal down a horseshoe-shaped gorge across a river.

The men hopped across the rocky bed of the river and made their way through the seemingly impenetrable foliage at the far end of an amphitheatre-like cliff that held a cave. Following the pug marks of the tiger, they reached a spot where the wall of the cave folded inwards and led to an opening. The mouth of the cave was quite big, but was far back enough to be hidden from view unless one was right across from it. Just a few feet left or right and one would almost certainly miss it!

Captain Smith looked at the cave intently. To him, it didn't look like a natural cave or one created by a river. He stopped in his tracks as he realized he was standing in front of a man-made cave—the jagged cliff had been cut and carved to perfection to create a most sophisticated structure!

Captain Smith quickly fashioned a make-do torch using some dried grass and lit it, and made his way into the cave. He walked through a long hall, flanked by painted pillars on both sides. As he walked further inside, there were shadowy outlines of ancient paintings all over the walls. At the other end of the hall, he found a circular dome— a Buddhist stupa carved out of the cliff slope.

Captain Smith was stunned to see these brilliant masterpieces. To mark his discovery, he brought out the hunting knife from his pocket and carved his name on the wall: John Smith, 28th Cavalry, 28 April 1819. (Not something that one should *ever* do in a historical site, but we guess Captain Smith didn't know any better!)

This is quite a story, but now come the all-important questions: Who created the caves that Captain Smith had unearthed? And why had they been lying hidden in the jungle, far from the human eye?

HOW DID THESE CAVES COME TO BE?

This is exactly what the archaeologists and historians wondered as the word spread about Captain Smith's great discovery. They followed his footsteps to the remote spot and started exploring the site.

Apart from the cave that Captain Smith had discovered (which is now called Cave 10), they found thirty other caves in the same complex that housed a head-spinning collection of paintings and sculptures. And together, these caves are one of the greatest wonders of ancient Indian art.

But what's so great about a bunch of old caves, you might wonder. Well, a cave is a cave is a cave—until you see the caves of Ajanta, that is. For starters, these are not natural caves but were created by human beings a long time ago. Imagine cutting and carving an entire mountainside into caves and then decorating them with paintings—and of a quality that has come to redefine the artistic tradition of not only India but the whole of South Asia.

Dating back to between the second century BCE and 650 CE, the caves are believed to be cut into the Sahyadri Hills—the mountainside above River Waghora—by Buddhist monks to serve as residences, temples and schools.

There are two differing views about when exactly these caves were built. Some scholars suggest that they were built under the patronage of the Satavahana rulers (230 BCE–220 CE). Though themselves Hindu, the Satavahana kings were liberal patrons of Buddhism and made land grants to Buddhist monks to build monasteries.

Some others trace back the history of the caves to a time when the great Mauryan king Ashoka ruled India (c. 268–232 BCE). He waged a war against Kalinga in 261 BCE and conquered the kingdom that none of his ancestors had managed to defeat. But his victory brought him no joy (something that war victories never ever do!); instead, it filled him with remorse when he realized

that so many lives had been lost in his desire to conquer. He decided never to wage war again and converted to Buddhism. It is believed that during the third century BCE, he wanted to bring to the people the teachings of Gautama Buddha and appeal to them to practise non-violence. To do so, he sent his monks far and wide with his message. Some of them, who were either skilled artists themselves or were accompanied by skilled artists, reached Maharashtra and began to excavate the Sahyadri Hills to build monasteries (or viharas) and prayer halls (or *chaityas*). The artists didn't stop there, of course—they filled what they'd built with the most beautiful paintings and sculptures.

Some historians also say that these paintings were actually not created by monks but by guilds of painters from Maharashtra, specifically Aurangabad, who were skilled in working in palaces and temples and hence had a very accurate painting technique. The members of the guilds were not necessarily Buddhists. So the monks who visited the caves would have told the chief of the guild what to paint. The monks would have supervised the job and paid the chief of the guild, who distributed the money among the painters.

HOW LONG DID IT TAKE TO MAKE THE AJANTA CAVES?

The archaeologists and scholars who have studied Ajanta Caves say that there are two distinct phases of work at Ajanta. The cave that Captain Smith walked into has inscriptions that date back to the second century BCE. However, most of the Ajanta Caves, and almost all the big murals, date from the second phase of construction,

which occurred under the patronage of the Vakataka king Harisena (475–500 CE).

In between these two phases, the caves were abandoned for over 400 years—from the first century CE to fifth century CE. (Just to give you an idea, the time gap between the earlier Ajanta paintings and the later ones would roughly be the same as the time gap between the Taj Mahal and Burj Khalifa!) Why was there such a long gap, you might wonder. Was it because the ruling dynasty fell into decline? Or did some political or social event of great magnitude happen, because of which the work on the Ajanta Caves was stalled for centuries? Was it a gradual desertion of the site or a sudden one? To cut a long story short, we haven't got a clue.

One thing is for certain though. When the work on the caves was resumed, it carried on for 250 more years— and what followed was the greatest example of classical Indian art.

WHAT'S PAINTED ON THE WALLS OF THE CAVES?

Almost every surface of the caves is decorated with narrative paintings from the Jataka tales, stories of the Buddha's previous births in both human and animal forms.

It is estimated that the oldest paintings in Ajanta date from only 300 years after the death of the Buddha. These earlier creations, both paintings and sculptures, do not show the image of the Buddha. Instead, symbols related to Buddha's life—such as the lotus, the white elephant, the wheel and the bodhi tree—represent him.

However, in the later works, which were done long after Buddha's death, he is depicted in human form. It is believed that his followers decided to paint his images so that they had something to hold on to while spreading the faith and teachings of the Buddha. The paintings comprise flora and fauna, gods and mythical beings such as apsaras (celestial maidens), yakshas and bodhisattvas (divine beings in Buddhism who were on their path to attaining salvation). A few of the caves in Ajanta also record that some of these paintings were sponsored by patrons, somewhat like how big companies or rich individuals now sponsor art shows or exhibitions.

In creating these brilliant pieces of art, the artists of Ajanta show a high degree of craftsmanship. If you look at these paintings closely, you will see how the artists have used fluid lines and bold brushstrokes. Outlines are used to enhance certain contours of the figures. Subtle gradation of the same colour and highlights (especially for facial features such as eyes, lips and chin) lend the paintings a three-dimensional quality. Human emotions such as greed, love and compassion have been captured in the Ajanta paintings with such great understanding, skill and drama that you can almost see the characters as real individuals.

The paintings also hold a mirror to the details of everyday life of the times during which these were created. The detailed elements of costumes and jewellery, places and spaces, utensils and weapons are a succinct representation of daily life from thousands of years ago. The scenes in the narrative paintings flow in diverse patterns: sometimes from top to bottom and in others, from bottom to top. Some even flow from left to right and vice versa. Though time has taken a toll on these marvellous works, with only

fragments surviving in many places, there's still a lot that helps us conjure up the past quite vividly.

It is believed in popular lore that anyone who tries to deface the paintings in Ajanta in any way or reproduce them is struck by bad luck—many attempts to make copies of the paintings to exhibit them in museums have been mysteriously unsuccessful. A British artist, Robert Gill, spent twenty-seven long years copying the Ajanta paintings, but in 1886, his entire collection was destroyed in a fire. The same fate befell some prints of the Ajanta paintings in London's Victoria and Albert Museum. A Japanese team, too, tried to take rice-paper impressions of the Ajanta sculptures, but these were eventually crushed in an earthquake! Is there any truth to this? Maybe. It could also be a superstition.

WHAT DID THE ARTISTS USE TO MAKE THESE PAINTINGS?

The artists painted rocks of Ajanta with . . . rocks! Yes, you read that right.

Today, we can buy paints in tubes and tubs in almost all the possible colours that we can imagine, but the artists living thousands of years ago didn't have it this easy. They had to make their own colours from natural sources, such as plants and minerals, and then mixed them with a liquid binder such as water or natural glue. Most of the pigments that the ancient artists used for the Ajanta paintings were obtained from the mineral rocks and stones available in the surrounding hills. They obtained the colour red from gypsum, white from lime, yellow ochre from the natural

soil, black from lamp soot, blue from lapis lazuli and green from the mineral glauconite or green sand. All of these were locally available, except lapis lazuli that was imported from northern India, central Asia and Persia.

The artists devised an ingenious new technique to apply these colours: a paste of powdered rock and clay was mixed with cow dung, chaff from cereals and rice husk. (Some suggest that some urine was also added to this paste.) This was first smeared on to the chipped rock surface. When it dried, a coat of mud or lime plaster was applied to smoothen out the surface. The outlines of the image were then drawn in pink, brown or black, and the colours were filled in with big brushes, made from the hair of squirrel tails or sheep's belly. This method is called tempera and is perhaps the reason why, even after so many years, the colours in these paintings glow with a brilliant intensity.

The artists also used many methods to light up the dark interiors of the caves. Apart from using torches made of dried twigs, they directed sunlight inside by using large metal mirrors. They also made shallow depressions on the floor and filled them with water to reflect sunlight on to the ceilings of the caves.

WHAT'S MORE TO THIS MYSTERY?

Thanks to a tiger, which fortunately Captain Smith never did find, we now know about the Ajanta Caves—they are the finest surviving art galleries from the ancient world that continue to mesmerize visitors with their beauty even today. The earliest of these caves were painted at around

the time that the beautiful stupas of Bharhut and Sanchi were being carved. The later paintings were created at the height of India's golden age in the fifth century—a time when the greatest masterpieces of Indian art and literature, such as the elegant sculptures of the Sarnath Buddha and Kalidasa's breathtakingly beautiful poem *Meghaduta*, were being created. Yet, there's a lot about Ajanta that we do not know.

Who were the great artists who worked on the Ajanta Caves? How did they manage to execute such a bold vision? What tools did they use to cut and carve these caves? Who funded the construction of these caves and the paintings in them? How did the artists produce such an array of work with such minimum light? Why did the inhabitants leave the site and for how long? Were the caves deserted gradually or overnight? For now, we don't have the answers. But, as they say, the right question is already half the solution to a problem. And hopefully someday, these right questions will lead us to the right answers!

BE AN ARTY-PANTS!

Perhaps the most famous of the Ajanta paintings is that of Bodhisattva Padmapani and Bodhisattva Vajrapani on the either side of Cave 1. Bodhisattva Padmapani is shown holding a lotus, and Bodhisattva Vajrapani is shown holding a thunderbolt.

Imagine you were born thousands of years ago and were posing for one of the Ajanta paintings. What object would you like to hold while the artist painted you? Remember, the object should tell something about your personality!

WHY WAS THE KAILASANATHA TEMPLE BUILT TOP TO BOTTOM?

Time period: Eighth century CE
Location: Aurangabad, Maharashtra

Have you ever built a complicated Lego structure and couldn't believe it was *you* who built it? This is exactly what seems to have happened to the architects who built the magnificent Kailasanatha Temple in the Ellora Caves of Maharashtra more than 1200 years ago.

But, instead of building this temple using bricks or blocks of stone as one would expect, they carved it out of a single humungous rock that was 200 feet long, 100 feet wide and 100 feet high! They scooped out the rock for a *really* long time and then, bit by bit, chipped and chiselled it to unbelievable precision until there emerged from the nothingness of the rock surface—as if by some divine sorcery—a most beautiful, multi-storeyed temple complex.

They did all this with just chisels, hammers and their bare hands! And once it was complete, according to an inscription on one of the temple walls, even the celestial beings in the skies were struck by its enormity, and the artists and architects of the temple couldn't believe that it was they who'd created it! Looking at the epic proportions of the temple, one does wonder if this was actually the handiwork of humans.

WHY WAS THE TEMPLE BUILT?

The legend goes something like this:

A long time ago—in the eighth century CE—there lived a king named Dantidurga. He belonged to the Rashtrakuta dynasty that ruled parts of central and south India. The king fell severely ill. All the doctors in his kingdom and those summoned from outside could not provide any remedy. They saw no hope for him and told his wife, Queen Elu, that he might not live for long. For days on end, the queen prayed to Lord Shiva for her husband's health. She made a vow that if her husband got better, she would build a huge temple dedicated to Lord Shiva that looked like the god's Himalayan abode, Mount Kailash, and would not eat anything until she saw the shikhara or the peak of this temple.

The king got better. It was time for the queen to fulfil her vow.

The king and the queen screened the nearby hills to find a suitable site to build the temple. They finally zeroed in on a huge basalt rock in the Charanandri Hills in Elapura, known today as Ellora, near Aurangabad. All the great architects and sculptors in the kingdom were called and ordered to work on the blueprints for the elaborate temple.

The king and the queen were impressed by all the ideas that the architects came up with and, in consultation with the royal priest, they fixed the date of laying the foundation of the temple. But, much to the couple's horror, they realized that if the temple is constructed from the bottom to the top, it would take years for the shikhara to emerge. The queen would starve to death much before the temple was completed!

The king invited the architects to come up with a solution to their peculiar problem, but no one was able to. Finally, a clever architect named Kokasa from Paithan came up with an ingenious idea—if they started the construction from the top of the hill, they could actually make the shikhara appear in a week's time! And so, it was decided that the temple would be constructed from top to bottom and not the other way round—much to the queen's relief who could now finish her fast in days!

Did all this really happen at all? Well, this story finds a mention in a tenth-century book called *Katha-Kalpataru* by Krishna Yajnavalkya, but there are no written records of the building of the temple other than this.

It is believed that since it was a mammoth architectural project, the temple's construction spanned across many generations of Rashtrakuta kings. While work on the temple started during King Dantidurga's reign, major work on the temple was done by his successor, Krishna I. Work on the temple continued for over a century after Krishna I's death in 774 CE, with different rulers adding their own flair. Two epigraphs (an inscription or a literary reference) link the temple to one Krishnaraja. It is not certain whether Krishnaraja and Krishna I are the same.

WHAT'S THE BIG DEAL ABOUT THIS TEMPLE?

Let's consider a few facts about Kailasanatha Temple. Each fact is followed by two options for you to pick.

1. The temple was a monolith—it was carved out of a single rock. It means that this temple was not really built—it was cut and carved, internally and externally,

out of a super hard, super big basalt rock. Imagine how much time and effort it would have taken the architects and the sculptors to shape a big rock into a temple!

Big deal ☐　　　　　No big deal ☐

2. It is estimated that 4,00,000 tons of rock was quarried out of the vertical cliff before the temple could begin to take shape. There were no excavators and earth movers back then. So how did the people who worked on this temple manage to scoop out all this rock? Also, where did all the basalt go? It seems to have vanished without a trace, just as the tools with which the rock face was scooped out! (Who knows, maybe the architects too were sticklers for 'Leave No Trace' policy that many of the modern conservationists believe in?)

Big deal ☐　　　　　No big deal ☐

3. Representing Mount Kailash, the Himalayan abode of Lord Shiva, the temple was executed top-down. This requires phenomenal precision and leaves absolutely no room for mistakes. Every single design element was meticulously planned and properly measured, for once it was cut, there was no way to change it. And, sure enough, no mistakes were made. It's a work of perfection!

Big deal ☐　　　　　No big deal ☐

4. The temple complex is huge—it measures some 164 feet long, 108 feet wide and 100 feet high, with three storeys. It is larger in area than the Pantheon in Athens, Greece, and one-and-a-half times as high!

Big deal ☐　　　　　No big deal ☐

5. Apart from the big halls with stairs, doorways, windows and beautiful sculptures, the temple also has bridges connecting one part to the other, underground passages, an elaborate drainage system with underground tunnels and even a sophisticated rainwater harvesting system. Plus, every inch of the temple has elaborate carvings that tell stories from Hindu mythology.

Big deal ☐ No big deal ☐

6. The temple is almost a kind of an encyclopaedia on the development of Indian temple architecture as it brings together the rock-cut temple traditions of western India, central India as well as southern India—one can actually trace the development of various styles of ancient Indian architecture over centuries in this monolithic masterpiece. It is believed that artisans from all over the country came to Ellora and worked on the Kailasanatha Temple, each bringing in their own local tradition along with them.

Big deal ☐ No big deal ☐

7. Oh, and it's as strong as a . . . erm . . . rock! It has endured time and stands resiliently even today!

Big deal ☐ No big deal ☐

So, going by the options you just chose, Kailasanatha Temple seems like a big deal, doesn't it? In fact, it is easily one of the biggest deals as far as the ancient Indian art and architecture is concerned.

WOW! BUT HOW?

How could the artisans of that time build such a technologically advanced structure without modern equipment? Archaeologists say that the only tools that were at their disposal would have been hammers, chisels and picks. So why did they choose such a hard rock to build this super complex structure in the first place—why didn't they use something softer such as limestone or sandstone? Without the rock cutters, how did they cut through the hard rock? And while they were chiselling the rock to shape it into the temple, how did they manage to do it without causing the rock to snap?

Historians believe that it would have taken over 7000 people over 200 years to build the temple. Who really were the genius (and tireless!) architects and artisans who worked on the temple? What compelled them to dedicate their entire lives to working with stone? It's also difficult to wrap one's head around the fact that the artisans who worked on this brilliant masterpiece, sought no fame. Didn't they feel like secretly signing on to one of their favourite sculptures or carvings as a way to assert their identity as one of the creators of this massive temple?

Another fascinating aspect of the Kailasanatha Temple is that every inch of this three-storey temple is carved with sculptures of various gods and goddesses and include stories from the Ramayana, Mahabharata and the Puranas. At the base of the main building are rows of stone elephants—as if these majestic creatures are holding the temple aloft. Lord Shiva himself is depicted in sixty-four different poses in the sculptures.

The most remarkable piece of work is perhaps the grand sculpture of the demon king Ravana trying to shake Mount Kailash with all his might as Lord Shiva pins him down with his big toe. The expressions on the faces and the body language are so dynamic that they make one wonder if the artists carved these from real life or from their imagination.

The upper panels are for the larger-than-life sculptures of gods, but there is some artistic fun below with human beings and animals. If you look closely, you will see some little quirks that the artists have put in—like monkeys going about their monkey business or musicians tuning their instruments. Was it the artists' way to bring in some comic relief or were they simply representing gods, human beings and animals in some sort of a hierarchy?

WAS IT ACTUALLY THE HANDIWORK OF HUMANS?

The temple holds many unsolved puzzles inside. Some researchers argue that it is beyond human capacity to make a structure of this scale and engineering.[3] Ancient alien theorists argue that the ancient architects and engineers had help from a much-advanced civilization[4]— some go as far as to say extraterrestrial help!—and that's how this temple was created.

There are many deep tunnels and narrow passages inside the temple. Though these can be seen from outside, some of them get too narrow for a human to enter.

[3] Childress, David Hatcher. *Technology of the Gods: The Incredible Sciences of the Ancients.* (Adventures Unlimited Press, 2000).

[4] Blavatsky, Helena Petrovna. *The Secret Doctrine: The Synthesis of Science, Religion and Philosophy.* (Penguin Books USA, 2009).

So, what was the purpose of these tunnels and passages? Was it some sort of a secret escape route? There are also many holes on the floor of the temple—the reason or purpose for these is unknown.

The temple is constructed in such a manner that the aerial view shows an X-like shape. Was it some kind of a secret symbol? Some researchers claim the existence of a huge underground civilization that thrived under the surface of the temple, and the narrow passageways connected to this underground city and the holes were either for the air circulation of the underground city or peek-holes, which were created to see if there were people walking on the ground surface.[5]

For now, all these are speculation as no real evidence has been found by the archaeologists to support this claim. Was the Kailasanatha Temple built by aliens? Probably not.

HMM . . . SO WHAT DO WE MAKE OF ALL THIS?

Over the years, the Kailasanatha Temple has teased the imagination of many historians, archaeologists and researchers who have been looking for the answers to its great mysteries. But, we guess, the temple is not going to let out its secrets too easily.

All we can do is visit, examine, research and ferret out more facts about the temple, ruminate on the rumours, analyse alternative explanations and come up with our own conclusions. But no matter who created it, when, why and how, the Kailasanatha Temple is a wonder to behold.

[5] Tsoukalos, Giorgio A., "The Ancient Alien Theory: Part Nine" in *AncientAlienPedia*, edited by C.R. Hale (2018); also, Giorgio Tsoukalos, in *Ancient Aliens*, Episode 9, History TV (2014).

When you stand before the huge temple, you can actually imagine scores of artisans chiselling away at the rock and, with each tap of their hammer, letting loose a mysterious story—which will give you goosebumps.

BE AN ARTY-PANTS!

Architects use detailed plans before they actually start working on a structure. These plans are called blueprints. The word 'blueprints', comes from a special kind of paper that architects use to make copies of their plans. They also use different kinds of symbols to represent the different parts of a building.

Below are some of these symbols. How about using them to create a simple blueprint of your home?

⌐Ụ̄	Door	▬::::▬	Window
▨▨▨	Wall	▥▥▥▥	Stairs
⌼	Water closet	⊠	Shower

ARE PITHORA PAINTINGS ACTUALLY MAPS?

Time period: Eleventh century CE
Locations: Gujarat and Madhya Pradesh

Long before Google Maps and Global Positioning·System, there were physical maps that helped people navigate from one point to the other and make sense of the world. These maps looked just like most maps do—abstract geometrical grids with criss-crossing lines and distinct symbols to represent countries and cities, oceans and rivers, mountains and deserts. This we all know.

But a long time ago, there were also maps that looked nothing like maps. Are you thinking, *Huh! What did they look like then?* Well, according to some art historians, these maps looked like beautiful paintings! Created by the people of a forest-dwelling community, these works of indigenous art are supposed to hold within themselves secret symbols, codes and directions. And, if one cracked the complex code in these deceptively simple paintings, one could discover a quaint little place in the middle of a wondrous forest! Hard to imagine, right? Not so much for the painters of the past who created the first Pithora paintings, it seems.

WHAT ARE PITHORA PAINTINGS?

It is often said that to know the art form of a particular place is to know the place itself. To look at Pithora paintings is indeed to get transported to the lush forests of central India, around the borders of Gujarat and Madhya Pradesh.

The history of Pithora art is so old that we can't put a date to it. This art form trails back long into history and find its roots in cave art, much before history came to be recorded. From the early humans, the painting tradition was taken forward by the tribal communities as a way to depict their social and spiritual lives.

One of the main communities who started making these paintings was the Rathwa community—which derives its name from the word 'rath' in the local language, meaning 'a jungle or a hilly region' where the community once lived. These paintings are called Pithora paintings. The name 'Pithora' comes from that of the chief god of the Rathwa community, Baba Pithora.

If you like drawing patterns by connecting dots, then you'd love Pithora paintings. But the dots on these paintings are not random—they are patterns that could be made to represent anything that the artists wish to, from their ancestors to local deities. In order to fulfil a vow or to keep away ill luck and invite good fortune, a particular Rathwa family, in consultation with the village priest or *badva*, engages the traditional artist of the community or *lakhada* ('a scribe or storyteller' in the Rathwi language) to create ritual murals related to creation myths or

legends of Baba Pithora on the walls of their house. Once the painting is complete, usually in three days' time, the priest interprets the many motifs in the paintings to the audience. Once the stories in the painting are regaled, a community feast follows, accompanied by music and dance.

These paintings usually consist of large, un-lifelike shapes of animals, birds and deities filled in with earthy yet bright colours, and then covered with an overlay of dots in several patterns and colours that stand out against the background. Because these patterns are solely in the hands of the artists who create them, no two paintings are similar and the work of each Pithora artist is unique. People who are familiar with Pithora paintings can tell who the artist is just by looking at the patterns created by them.

WHAT'S WITH THE MAPS THEN?

Most folk and tribal art forms that are practised in India have some myths and legends attached to them. Pithora paintings are no different.

The main legend attached to the origin of Pithora paintings is that they are actually mysterious maps. The story goes that in the eleventh century, Bharuch—a small village at the mouth of River Narmada in Gujarat—was slowly gaining popularity as a trade centre, with both Indian and foreign traders coming here to sell their goods. But then, there arose a peculiar problem that prevented Bharuch from becoming a buzzing trade centre.

The roads that led to Bharuch were difficult and dangerous, for they passed through thick forests that were infested by dreaded bandits who roamed in gangs, looting and killing people. Many traders had fallen victim to these notorious gangs and, as the news spread, other traders were scared to venture into the deep, deadly forests.

The tribal communities who dwelled in these parts saw an opportunity to make some money. They started escorting the traders through the region they were pretty well-versed with, in exchange for silver coins. It was a flourishing business. The men from the tribe escorted the traders till the onset of monsoon, when the trade stopped because of the rains. They cultivated the land for four months till Dussehra. And after Dussehra, as the trade picked up again, they continued till Holi. On the occasion of Holi, the silver coins collected by the escorts were handed over to the leader of the tribe and distributed equally among all the escorts.

To keep their land a mystery to the outsiders and to ensure their livelihood was protected, the leader of the tribe started making coded maps in natural colours. These maps depicted the rough passages, wooded hills, swamps and coves in abstract symbols that could only be read and understood by the people of the tribe—a very ingenious and intelligible method of representing their terrain. In order to organize the escorts as a community within their tribe (like a state within a country), the leader ordered the escorts to make these paintings on the walls of their houses.

To show loyalty towards the leader and to ascertain their citizenship in this niche community, some escorts

inscribed these paintings on the walls of their houses and came to be known as the Rathwas. Those who disagreed, because they considered themselves superior to the others on account of their ancestry, came to be known as the Talavias. The Rathwa community settled atop the seven hills that surrounded the forests of Chhota Udepur and Panchmahal districts of Gujarat, while the Talavias stayed at the foothills.

The practice of escorting the traders using coded maps is said to have continued till about 1812, when the British imposed restrictions on trade and put a stop to it.

CAN WE GET TO THE SECRET SYMBOLS?

Have you ever found yourself looking at something familiar that suddenly starts to look totally strange, as if they are concealing some kind of a secret? The Pithora paintings might give you that feeling.

If you look at a Pithora painting, you'll probably find them pretty straightforward, depicting an ordinary scene, with flora and fauna, rivers and mountains, rural lifestyle and daily chores—painted in the trademark dotted style of the Rathwas. And yet, for a long time, art historians have been breaking their heads over the details in these paintings that complicate any simple understanding of them. Many believe that Pithora painters managed to sneak secret symbols into their artworks that no one other than one of their own could decode.

Some of the recurring motifs in the Pithora paintings seem to be symbolic of topographical details of the

region. The rectangular fence around the borders in these paintings, for instance, is assumed to be defining the geographical area over which the Rathwa tribe is spread—stretching to the Arabian Sea in the west, Bharuch in the south, and Indore in the north and the east. The seven hills that surround this region are said to be represented by seven horses. The wavy lines that usually divide the Pithora paintings are believed to be a representation of River Narmada and two tigers, the mouth of the river. Other details, such as fields, trees and wildlife, are also present in some of these paintings. (Could it be to throw the suspicious outsiders off the scent?)

What is fascinating, however, is that the relative positions of these topographical details on a real map are quite close to the symbols in some of the early Pithora paintings. Could this be coincidence? Maybe. Maybe not. In any case, once you start thinking about these hidden secrets, you can never look at a Pithora painting without wondering or looking for markers again.

DO RATHWAS STILL MAKE THESE PAINTINGS?

Many of them do, but there have been certain changes over time. After the British stopped the practice of the Rathwas escorting the traders, the paintings became more of a ritual.

According to oral history that has been passed down, there was a time when the Rathwa villages were ravaged by a terrible drought. The land had broken into tens and thousands of fissures and not a patch of cloud could be

seen anywhere. The Rathwas took a vow to please Baba Pithora to win a boon and get rid of the drought. Soon after they took the vow, it started to rain and the earth became all green again! As a part of the several rituals that the Rathwas had organized to fulfil the vow, they painted the walls of their homes with images of Baba Pithora and his wife Pithori Devi on horseback.

From then on, in times of hardships, the Rathwas consult the village priest and take vows to get rid of difficulties and undo bad omens. When the wish is granted, the family engages the lakhada, who puts together a team of ten young artists, to make a wall painting of Baba Pithora and other gods, in accordance with certain well-defined rules.

Traditionally, Pithora paintings were made using bamboo brushes and natural colours mixed with cow's milk on walls tempered with white clay, but now, of course, acrylic colours and synthetic brushes are also used. There are over fifty varieties of Pithora wall paintings— with the smallest measuring about one-and-a-half feet and the largest about ten feet—and over 165 different motifs are used.

Today, these paintings have found their way into galleries and museums, and the canvas has replaced the brick walls. But if you look at some of these paintings, you will still find intriguing elements such as railway tracks, aeroplanes and even computers in them! Are these just the depiction of the changing lifestyle of the community or coded elements of some mysterious maps? What do you think?

IS THERE REALLY MORE TO PITHORA ART THAN MEETS THE EYE?

When one is dealing with stories that are even part myth or legend, they inhabit a place where real and imaginary, reality and fantasy are constantly overlapping. In the illustrations, the broad topographical details—like the seven hills and Narmada River—match the early Pithora paintings. But otherwise, they are—in the cartographical vein—largely not plottable. And there is no way for us to ask the creators of the eleventh-century Pithora paintings what they were thinking when they made the early paintings.

Maybe these paintings were actually created as maps, and hidden in their bold strokes were the actual contours of a place. While making these maps, however, did the idea of capturing the big, sprawling, ever-changing landscape on a much smaller canvas ever daunt the artists? How did they champion the art of concealment? Who came up with these most clever codes and secret symbols such as trees, birds, the sun and the moon, and animals to denote topographical details? How could the artists cram everything that was important to them in a painting? What was important to them?

Or maybe the artists didn't set out to create maps but just beautiful paintings. And all the possible meanings and interpretations are mere speculation, inspired by travellers' tales and fertile imaginations.

The secrets behind the early Pithora paintings haven't been pried loose, at least not fully. But if you look at these paintings closely, they will make you think about them in new ways—and might just even help you tease out the hidden meanings in them!

BE AN ARTY-PANTS!

Pick up a notebook, grab a pen or sharpen a pencil. Put on your spyglasses and wear your most intelligent expression. Now, exercise your little grey cells and create a coded map of your room, your school or your neighbourhood.

Take a tour of the place—if you can—to get the lay of the land. List down everything that will go on your map, like rooms or trees or streets or parks. Think of substitute images or symbols as codes for these things. Be as imaginative as you can so that no one can crack your coded map.

It's execution time now! Sketch your coded symbols where the original objects, like rooms, parks and streets on your map should be. Done? Great! You're well on your way to becoming a cartographer or a cryptographer!

WHY ARE WOMEN ARTISTS MISSING IN MUGHAL ART?

Time period: Late sixteenth to early seventeenth century CE

Locations: Fatehpur Sikri, Agra and

Allahabad, Uttar Pradesh and Delhi

Of the many treasures in the British Library in London, there's one gorgeously illustrated manuscript of *Khamsah-of-Nizami*, an anthology of five poems by the twelfth-century Persian poet Nizami Ganjavi. In this, there is a beautiful painting—a detail of which shows a woman painting her self-portrait as one of her attendants faces her holding a fancy mirror.

This painting dates to the 1590s. It is believed to have been done by Sahifa Banu, a Mughal princess and miniature painter who achieved fame during the fourth Mughal emperor Jahangir's reign. One of the three or four paintings attributed to her, it raises several questions.

While there is so much written about the male artists who worked in the royal ateliers of the Mughal courts, why don't we know about the women painters of the Mughal times? Were there women artists, to begin with? If so, who were they and what kind of works did they create? Where are these works created by them? How different were their aesthetic sensibilities from their male peers? And, perhaps most importantly, why have these women artists not been talked about in Mughal history?

WHAT DO WE KNOW ABOUT WOMEN OF THE MUGHAL COURTS?

In 1526, the Central Asian semi-nomadic warlord Babur rode into Delhi after defeating Ibrahim Lodi, the last sultan of Delhi in the first battle of Panipat, ushering in a new dynasty to rule Hindostan. Waves upon waves of cavalry moved down the streets of the city, led by its fierce-looking leader and surrounded by foot soldiers who were trying to keep away large crowds that had gathered to catch a glimpse of the new ruler.

Babur also brought his harem, or household, which included women and children. Seated on imperial elephants, his many wives, elderly grandmothers and aunts, unmarried sisters, widowed relatives and female attendants travelled with him everywhere. They lived in tents during his various conquests and created a home on the go. And, over the course of the 300-year-long Mughal rule in India, the harem evolved into a private physical space for the womenfolk called the zenana, or the women's quarters of the household.

For the longest time, the Mughal zenana was written about as an exotic space of extravagance where women spent all their time beautifying themselves, perhaps because the private quarters of the Mughal women were inaccessible to the early European travellers who visited the Mughal courts, leading to their fervid leaps of imagination while documenting their experiences in their memoirs and official records. But, in effect, the zenana was almost like a mini city that required good administration and diplomacy for it to run smoothly.

The zenana was well ordered and each woman had a rank and purpose. The women were educated and had

power and agency, something that was unheard of at the time anywhere else in the world. They were schooled in different languages such as Persian, Turkish and later Hindustani, and a few of them also wrote memoirs and biographies. They engaged in politics and administration, poetry and music, weaving and embroidery, art and calligraphy, hunting and other kinds of adventurous sports. They were involved in trade, wrote farmans, or orders, had seals issued in their names, and even had control over their own wealth, unlike their European contemporaries. With their own money, they sponsored many buildings and monuments that are strewn across the Indian landscape.

There are numerous examples in Mughal history of women who exerted influence and had incredible talent and ambition. Gulbadan Begum, daughter of Babur and sister of Humayun, wrote a biography of both of them; Humayun's widow and Akbar's mother Hamida Banu Begum built Humayun's tomb that later inspired the Taj Mahal; Maham Anga, the milk mother of Akbar, was politically astute and, at one point, was even considered the vice-regent of the empire; Nur Jahan, Jahangir's wife, took active interest in international trade and had coins issued in her name; Jahanara, Shah Jahan's daughter, wrote two Sufi treatise and several pieces of fine poetry; Zeb-un-Nisa, Aurangzeb's daughter, sang well and composed music.

It wasn't just the women in the royal zenanas who pursued different vocations; women in general participated equally with the men in several professions during the Mughal times. They did all kinds of works. Women were the *mahaldaars* and the *daroghas*, the royal guards of the Mughal zenana; they were trained musicians and dancers; they were gardeners and weavers; they were news writers

and secret agents; they were cooks and washerwomen; they were labourers and brick workers, too.

WERE THERE WOMEN ARTISTS DURING THE MUGHAL TIMES?

There have always been women in the arts, from the prehistoric times to the present, though sadly, our history books often do not name them. Women in the Mughal zenana had a keen interest in the various forms of arts— they commissioned paintings and some of them even painted. In fact, scholars believe that art as a discipline was taught in the women's quarters during the Mughal times.[6]

Till about the seventeenth century, women were hardly ever the main subjects of paintings. This changed significantly when Jahangir ascended the throne and encouraged the depiction of women in miniature paintings. Many individual portraits of Mughal women as well as paintings of life inside the Mughal zenana were created during this time. There are also paintings of women going out for hunting expeditions and visiting important holy places. The women are depicted in fine clothing and rich jewellery, with explicit detailing and elegance.

Most of these paintings with women subjects, however, are generic and not realistic depictions of actual women, for the male artists were forbidden access to the female quarters and hence painted women from their imagined ideas of femininity. But there are a few paintings that have

[6] Mukhoty, Ira. *Akbar: The Great Mughal* (Aleph Book Company, 2018).
Galloway, Francesca. Online Catalogue: *Women at the Mughal Court: Perception and Reality* (9–23 May 2020).

realistic depictions of women from the royal zenana. So, it can be safely assumed that these paintings must have been commissioned to women artists of that time.

In 2012, an eminent art historian and curator, J.P. Losty put together an exhibition catalogue of Indian and Persian paintings from 1590 to 1840. In one of the miniature paintings, Emperor Jahangir is shown seated on a *takht* in the zenana, his back supported by a big bolster. In front of him is a woman, most likely his wife Nur Jahan, offering him a cup of wine. He is surrounded by groups of women—the other members of the royal zenana. One of the women is shown holding an album or a portfolio.

It was quite common during Jahangir's time for the artists to feature themselves in the paintings they created. Losty suggested the possibility of this being a self-portrait of the woman artist who created this painting. In the catalogue, he writes: 'The group at the bottom-left corner includes a woman holding an album or portfolio, a well-known sign in the work of artists such as Bichitr, Bishndas or Balchand, which is taken to mean that this is a self-portrait of the artist of the main picture. This would suggest in our painting that the artist is a woman in the zenana . . .'[7]

During Jahangir's time, the miniature paintings started to be bound together in imperial albums called *muraqqas*. These were like big sketchbooks with beautifully intricate miniature paintings. One of these muraqqas is the 300-page-long *Muraqqa-e Gulshan*, or the 'Gulshan (garden) album'. It is widely recognized as Emperor Jahangir's oft-mentioned but largely unseen opus that was

[7] Forge, Oliver, and Brendan Lynch. *Indian and Persian Painting 1590–1840: Exhibition*. New York. London, 2014.

looted along with other Mughal treasures by Nadir Shah of Persia when he attacked Delhi in 1739 during the reign of the Mughal emperor Muhammad Shah. The album, which is now in the Golestan Palace Library in Tehran and has only been shown in bits and pieces in exhibitions around the world, is said to include works of at least three Mughal female artists amongst the more well-known male artists of the Mughal atelier, such as Aqa Reza Al-Heravi, Basawan and Nanha.

WAS SAHIFA BANU ONE OF THESE ARTISTS?

The Mughals are known to be memory keepers. They wrote memoirs and recruited court historians in large numbers to document their life and times.

Several male Mughal artists are well known for the same reason. The practice was for artists to write their names below each miniature, which has helped historians and scholars identify many of the artists who worked in the royal ateliers at different times. The painters in the times of Akbar and Jahangir, for example, include Basawan, Ustad Mansur, Abu al-Hasan, Bichitr, Bishndas, Nanha and Daulat. These artists also created self-portraits as well as portraits of their artist colleagues that further helped historians identify them.

The same cannot be said about the women artists of the Mughal courts. There's not much information on them and their works. The names of some female Mughal painters of the seventeenth century, however, are known. They were probably members of the imperial family or women of very high status. One of the most famed of these was Sahifa Banu.

Many believe that Sahifa Banu was a princess or a high-ranking woman in Jahangir's court. At least three miniature paintings have been credited to her—all said to be inspired by Persian artists.

The first painting depicts a scene from the Persian poem *Mantiq al-tair* (Language of the Birds), in which a hoopoe relates a series of tales to its fellow birds. This scene depicts a tale of a son mourning the death of his father, in response to a bird expressing its fear of death. This painting, attributed to Sahifa Banu, is strikingly similar to a fifteenth-century painting of Behzad, one of the greatest Persian miniaturists.

A second painting attributed to Sahifa Banu is similar to another famous painting by Behzad. It illustrates the building of Khawarnaq, a famous medieval castle constructed by the Arab Lakhmid kings near their capital al-Hira.

The third painting attributed to her was a miniature that features the Persian ruler Shah Tahmasp. It is believed that when Humayun, Babur's son and the second Mughal emperor, was defeated in a battle by the Afghan chieftain Sher Shah Suri, he fled to Persia and took shelter in Shah Tahmasp's court. And when he came back to India after fifteen long years, he brought with him two of the finest miniature painters from Tahmasp's royal studios to train the artists in his court.

In the painting by Sahifa Banu, Shah Tahmasp is shown sitting on a floral carpet under a tree at the edge of a river. She experimented with different perspectives in this painting—while Shah Tahmasp and the tree are shown at eye level, the stream and the carpet are shown from a top view.

Though Sahifa Banu seems to be greatly inspired by the Persian artists, she did not copy them blindly. She introduced new elements into her work to display her unique skill. She used shading in the modelling of details to give the paintings a three-dimensional effect and also used multiple perspectives, which is characteristic of paintings done during Jahangir's reign. This further establishes Sahifa Banu's affiliation with the royal studios.

DO WE KNOW ANYTHING ABOUT THE OTHER WOMEN ARTISTS OF THE MUGHAL TIMES?

Mughal rule coincided with the arrival of the Europeans in India for trade and more. And so, the works of the European artists were not unknown to the artists in the Mughal ateliers. Jahangir is believed to be greatly influenced by the European style of painting and encouraged the artists in his studio to emulate western artists. The women artists, too, made copies of western paintings—but in their own style.

A painting attributed to a woman artist named Ruqaiya Banu, for instance, depicts a European male figure sitting under a tree with his chin resting against his shoulder and his elbow on his knee. The painting is similar to a part of a larger biblical scene engraved by the Flemish artist Jan Sadeler based on a painting by another artist Crispijn van den Broeck. In the original painting, Adam is shown with Eve and their two children in the meadows, surrounded by a turtle, a goat and a sheep. In the background, one can see people going about their daily business—cooking, farming—showing symbolically god's many blessings.

The Mughal version is similar and yet quite different. It shows a less muscular but well-toned male figure

sitting under a golden tree, with a dog as his companion. The features and expressions of the two figures also differ vastly. While the man in the original gazes down at something with a tilted head, the one in the Mughal version is shown in profile, with a less angular face, and eyes closed as if in a moment of reflection. On closer observation, one can see how while the original is a depiction of a biblical text, the Mughal version is actually an allegory. Ruqaiya Banu, thus, took a purely European subject and gave it her own spin—which is quite telling of her superb skill and imagination!

Another painter who followed the trend of creating European art-inspired miniatures and worked during the reign of both Akbar and Jahangir is Nadira Banu. A composite painting in the Gulshan album has a painting of St Matthew with a lion. An inscription on the painting mentions Nuri Nadira Banu, a pupil of Aqa Raza—a well-known painter in the service of Emperor Jahangir.

Another painting from around the same time is inspired by an engraving of the Martyrdom of St Cecilia by the Flemish artist Hieronymus Wierix. A saint who is believed to have lived in the third century CE, St Cecilia was one of the most revered early virgin martyrs of Rome. In the original engraving, St Cecilia is shown lying face down with many wounds on her neck. The Mughal painter who recreated this painting decided to remove the wounds from the neck and added a beautiful calligraphic inscription below it—a ghazal by Amir Khusrau about the suffering caused by love and the pain of abandonment, thus lending a more contemplative feeling to the painting. The lower margin of the painting bears the lettering 'Nini', who is believed to be a female artist in Jahangir's court. Did the

story of Saint Cecilia, a woman who stood up for what
she believed in, inspire Nini to create this painting or
did she create it on the emperor's instructions? No one
knows for sure!

Women painted diverse themes and subjects. A leaf
from the Gulshan album depicts a tussle between two
elephants (elephant fights as a part of court entertainment
were common during Mughal times) as the mahouts
hang on grimly to the harness ropes. The painting,
dating to c. 1600-1601 CE, is ascribed to a woman artist,
Khurshid Banu.

What's unfortunate is that though there are a few
shining examples of paintings created by women artists
during the Mughal times, not much information about
their backgrounds and their lives is available.

AND WHY IS THAT SO?

When one flips through the tomes of Mughal history, one
could easily come to believe that there have not been any
women artists from that period. While there are plenty of
women depicted *in* the artworks of the Mughals, artworks
by women are quite rare. The lack of documented
contributions by women artists in the Mughal art history
raises a compelling question—why?

History can never be the whole picture—it's always from
the point of view of the person who's writing it. While it does
give us an insight into our past, it is only a part of the overall
reality and there are chances that people who record history
might have overlooked (or have skewed views of) certain
groups or individuals due to their gender, ethnicity or social

standing, among many other things. In writing the glorious past of the Mughal emperors, for instance, women have been grossly overlooked by biographers. It is often forgotten that there was a remarkable number of strong women's voices during the Mughal times. Over the years, however, historians and scholars are trying to correct this by writing about Mughal women with agency—the ones who built tombs and bazaars and caravanserais, who took solo voyages across the world, who wrote biographies and poetry. And yet, their contributions in the arts remain a missing detail on the grand canvas of Mughal history. One can find the names of many male artists, but a thick veil of anonymity surrounds most of the women artists of the period.

While we cannot really undo the past, we can maybe build a richer and more inclusive picture of art going forward. We can celebrate the works of those who have been 'forgotten'. And we can be thankful that there are at least a few surviving miniatures by women artists from the Mughal times, because of which the veil of anonymity surrounding them lifts, albeit momentarily, and we get a rare glimpse of their thoughts and imagination.

BE AN ARTY-PANTS!

Have you ever drawn yourself? Several Mughal artists created self-portraits—some even inserted their self-portraits discreetly into the crowd scenes in composite paintings. Looking at these self-portraits, we get an idea of what the artists thought and felt at the time they were creating these paintings.

How about you creating a portrait of yourself in a Mughal miniature pose? Look up Mughal portraits on the internet. Choose a pose that you like. Click a selfie in that pose. Now sketch and colour it—and make sure that history has no way of forgetting you!

WHAT IS THE MYSTERY OF THE INDIAN YELLOW?

Time period: Sixteenth to nineteenth century CE

Locations: Munger, Bihar and Bengal

Today, all an artist looking for a particular colour has to do is go to an art shop and pick up a tube of the colour she wants off the shelf. But centuries ago, creating a pigment depended on the available natural material and getting creative with them.

Most artists worked with pigments that were present in the colours of flowers, leaves, bark, roots, rocks and minerals. They extracted and used them either on their own or blended them together with other natural pigments to create variations.

In the sixteenth century, there developed a distinct genre of miniature paintings called the Ragamala that used the most dazzling, luminous colours, extracted from natural sources, to depict various moods and minds. Some of these colours were white, blue, red, green and black, which were obtained from burnt conch shell, lapis lazuli, vermilion, oxidized copper and lampblack, respectively.

Of all the colours that were used in these paintings, there is one that stands out: the Indian yellow. It's not any yellow, mind you. It seems to hold in harmony the many

different yellows—the flaring yellow of the spring and the deep yellow of the summer, the golden yellow of the mustard and the ripe yellow of the mango, the swirling yellow of the butterfly and the buzzing yellow of the bee. It had a strange glow that resisted fading and, in fact, brightened when exposed to sunlight, making it perfect for rich glazes and vibrant washes. When mixed with blue, it gave a rich gradation of greens and when mixed with red, it produced a wonderful range of oranges.

The source and origin of this colour is shrouded in mystery. What little is known about it is unverifiable since it went out of production in the early twentieth century, with no written record of its source or extraction process. All that is left is a small quantity of this pigment in museum collections and the confounding questions— where did the Indian yellow come from? And where did it go?

WHAT ARE THE RAGAMALA PAINTINGS?

Most of us have a bunch of favourite songs, each serving a different purpose—there could be one that pumps us up in the morning to get up and start our day; one that makes us feel better when we're feeling sad; another one that's bouncy, for when one is happy; and yet another one that's so mellifluously soothing that it lulls us to sleep. We often classify our favourite songs according to the time of the day or mood. This practice goes back at least 500 years.

Don't believe this? Well, there's a visual proof to this: the unique series of miniatures called the Ragamala paintings.

'Ragamala' means 'a garland of melodies'. 'Raga' also means something that colours the mind with a definite feeling or emotion. And that's exactly what the Ragamala paintings do!

Often done as miniatures, each Ragamala painting is the artist's interpretation of a two-line poem (mostly written in Sanskrit), set in a particular raga or musical melody that evokes a certain emotion. This genre of miniature painting that brought together poetry, music and painting became popular between the sixteenth and the nineteenth centuries, and Kota, Bundi, Bikaner, Marwar, Kangra, Basohli, Chamba and Bijapur became some its major centres.

Consisting of an album of 36–42 painted folio sheets, Ragamalas were organized according to families; with Ragas (principal musical modes), their wives Raginis (secondary musical modes) and their sons and daughters (Ragaputras and Ragaputris, respectively). Each of these musical modes had a special mood—such as love, devotion, happiness, celebration—associated with it. These musical modes are also linked to six seasons—summer, monsoon, autumn, early winter, winter and spring—and times of the day: dawn, dusk, night, and so on. (To perform a raga at an inappropriate time was considered not only unaesthetic but also something that could bring ill luck since most of the ragas were linked with Hindu deities.) Immensely expressive and delicately executed, these paintings were highly coloured in a dramatic contrasting of various hues, such as lampblack and warm red, silvers and cool greens, ash grey and, of course, the fabled Indian yellow.

WHEN DID THE INDIAN YELLOW MAKE ITS WAY INTO THE ARTISTS' PALETTE?

It is believed that the pigment originated somewhere in India, Persia or China in the fifteenth century and was used liberally in Mughal, Rajasthani and Pahari miniatures as well as murals until the early twentieth century. Before the invention of the Indian yellow, the Persian yellow, which was obtained from the stigmata of the saffron flower, and turmeric were the main yellow pigments used.

When the brilliantly luminescent Indian yellow was invented, it became the preferred yellow of many artists. From the flowing drapery of the gods to the rich flora and fauna, the Indian yellow was used to colour a number of striking elements in the paintings of this period. Because of its versatility, transparency and lightfastness, it became extremely popular.

The British in India at the time noticed the gloriously glowing yellow used in the miniature paintings. They loved it so much that it soon began to be exported to various parts of Europe through the ports of Calcutta in small, compact balls (2–4 ounces in weight), with a brown-green exterior and a rich yellow interior. By grinding and mixing the balls with a binding agent such as egg, oil or gum, the characteristic golden yellow, transparent paint was produced.

Many European artists such as Johannes Vermeer, J.M.W. Turner and, the most celebrated of all, Vincent Van Gogh used this colour extensively. One of Van Gogh's most

recognizable works *Starry Night*, for instance, uses this pigment—the bright yellow moon peeking through the swirling dark blue sky is painted in this colour.

And so, through the eighteenth and the nineteenth centuries, wooden boxes of this strange-smelling pigment would arrive at the London docks and the colourmen, whose job was to process and sell paint to artists, picked up the deliveries. They had little idea of how it was made or what it was, but the pigment had become a crucial component of the European painters' palette. Many origin stories came to be ascribed to the pigment—some said that it is a plant-based pigment, while others contended it to be animal-based.

Several speculations began to make the rounds. In 1786, amateur artist Roger Dewhurst wrote to some of his friends that perhaps it was urine mixed with turmeric—the reason why the pigment smelled peculiarly pungent. George Field, a leading English chemist and colourman suggested that it was 'the urine of camels'. Others thought it might have come from snakes or buffaloes. In 1844, a Scottish chemist John Stenhouse noted in a science journal that the colour came from a plant sap that was precipitated into magnesium and then boiled down to form small balls. French painter Jean-François Léonor Mérimée claimed in his 1939 book *The Art of Painting in Oil and Fresco* that the colour was derived from a bushy tree. But because none of them could satisfactorily explain the origin of the pigment, it gave rise to more wild assumptions until, of course, the most accepted version of how the fabled pigment of Indian yellow was made came to be.

WHAT WAS THE INDIAN YELLOW MADE FROM?

In 1883, some scientists, in their earnest attempt to unravel the mystery, approached the celebrated botanist and the director of the Royal Botanic Gardens at Kew in England, Joseph Dalton Hooker, to help them in tracing the source of the pigment of the Indian yellow. Hooker had spent many years in India, painstakingly cataloguing the various plants in British India for his voluminous book *Flora Indica* and was familiar with the lay of the land. He got in touch with some officials in Calcutta to help him trace the source of the pigment. The officials assigned the job to an expert in the materials of Indian arts, a civil servant named Trilokyanath Mukharji.

Mukharji travelled to the only place from where the pigment was sourced—a town called Monghyr (modern-day Munger) in the Bihar region. There he watched a community of *gwalas* or milkmen, who fed their cows an exclusive diet of fresh and dried mango leaves with a dash of turmeric and encouraged them to urinate into small sandpits. He found out that it was from the urine of these cows that the pigment was created!

The gwalas collected the cows' urine in a sandpit, cooled it and concentrated it by heating it over fire in an earthen pot for long durations of time, which made the pigment precipitate. They would then strain the liquid through a sheer fabric and compress the sediment into small balls, drying them over charcoal fire and then in the sun.

Mukharji thus claimed that the source of the pigment of Indian yellow was animal in origin. He also noted that the gwalas sold the pigment to some local traders who transported it to Patna and Calcutta, from where it was

shipped to Europe. The annual production of the pigment was £10–15,000 (roughly Rs 10–15,00,000 in today's worth) and it was a thriving and profitable business.

HOW DID THE PIGMENT DISAPPEAR THEN?

The popularity of this pigment had a downside. A diet consisting of only bitter mango leaves and the denial of a normal bovine diet left the cows malnourished, making them sick. Mango leaves are also known to contain a toxin, which is also found in large quantities in poison ivy. So, the cows that were used for the manufacture of the pigment died in just two years.

Detailing out the origin and manufacturing process of the pigment and the plight of the animals, Mukharji sent a letter to Hooker in 1883, along with a ball of Indian yellow from Monghyr, a bottle of cow urine that was the pigment source, an earthen pot used for boiling the mixture, a sack-like cloth that was used to filter the boiled solution and a clump of mango leaves.

In 1884, Hooker published Mukharji's findings in the journal of the Royal Society of Arts.

Soon after, the pigment disappeared from the market—rumoured to be as a result of the inhumane treatment of the cattle in the production process. The production of Indian yellow was banned by the British under the provisions of the Prevention of Cruelty to Animals Act that was passed by the Government of India in 1890. Finally, it fell out of favour completely by the beginning of twentieth century and was no longer commercially available.

THE MYSTERY IS SOLVED, OR IS IT?

Apart from the letter that Mukharji wrote to Hooker, there are no other written sources that mention the process of creating the Indian yellow. Mukharji's account has been accepted as well as contended by many art historians and scholars, agreeing or disagreeing with him in parts or as a whole. Victoria Finlay, the author of *Color: A Natural History of the Palette*, for instance, retraced Mukharji's steps to Munger in 2001 and travelled the region extensively but found no evidence that the Indian yellow had ever been made there. The locals knew nothing of the methods that Mukharji described in great detail as being so widely used only a couple of centuries ago. She found no record of the pigment's ban in the archives, too.

In 2016–18, two scientist-conservationists, Rebecca Ploeger and Aaron Shugar, from the State University of New York, set out to investigate Mukharji's findings and carried out comprehensive testing on the samples Mukharji had shared with Hooker. They found that the samples had a small amount of hippuric acid, which is present in animal urine. They also found euxanthic acid, which could be a possible by-product of the metabolic processing of mango leaves.

So, are Mukharji's findings true? It does provide an explanation for the unusual nature of this astonishing colour and a reason for its disappearance. However, it is largely uncorroborated with other reports and therefore sometimes disputed by researchers.

The people who made the Indian yellow faded into history along with the pigment and, a couple of generations later, there is no public memory left either of

them or of the trade. What remains though are the nuggets of the original Indian yellow in archives and museums. But like many other colours, synthetic Indian yellow has replaced the original one. It might not be the same, but it's definitely more cattle-friendly.

BE AN ARTY-PANTS!

Since all the different colours are just a stationery shop away from us, it's quite easy to forget that in the not-too-distant past, all the paints were made by artists themselves, directly from animals, plants and minerals. How about travelling back in time by creating our own all-natural colours?

Yellow: Take one teaspoon turmeric and mix it well with four teaspoons of besan or gram flour. Sieve the powder at least a couple of time using a fine strainer. Mix the powder with a small splash of water. (Remember, you don't want the paint to be super runny, but you want enough so that it's not grainy!)

Red: Take two teaspoons of turmeric powder and spread it out on a plate. Now squeeze lime juice on it. The acidic lemon will react with the turmeric and turn it red in colour. Let it dry in a cool place. Don't keep it in the sun, for that can bleach the colour. Once the powder is dry, sieve it a couple of times using a strainer. Mix it with a little water and use it!

Green: Add two teaspoons of mehendi to two teaspoons of maida or all-purpose flour. Mix and sieve a few times to get green colour. Add some water to make it pasty. The green colour is ready to use!

You can now mix these colours to create various others and paint your perfect painting.

WHO WAS BANI THANI?

Time period: Eighteenth century CE
Location: Kishangarh, Rajasthan

Which is the world's most famous portrait of a woman with a mysterious smile? No points for guessing—it's the *Mona Lisa* by the famous Italian artist Leonardo da Vinci. But do you know that there's an Indian Mona Lisa as well?

A series of iconic Rajput miniature paintings from Kishangarh, Rajasthan, depicts a dainty young woman dressed in the finest of silk garments with cascading jewels. She can be seen holding her translucent embroidered veil in one hand and a pair of lotus buds in the other. Often compared to Mona Lisa, her subtle, beguiling smile has captivated onlookers for over four centuries. The name of this woman is Bani Thani (or Miss All Made Up). But why is she called so? Who created her? Was she an actual person or just a fragment of an artist's imagination? And what is she smiling about?

WHAT EXACTLY ARE MINIATURE PAINTINGS?

All across the world and across centuries, artists have drawn beautifully in manuscripts or books. One such tradition of illustrating ancient manuscripts with astonishingly detailed illustrations was the miniature painting tradition.

In India, miniature paintings were first made by artists of the Pala dynasty of Bengal in the ninth and tenth centuries to illustrate Buddhist texts on palm leaves. With the introduction of paper in the twelfth century, illustrations on paper manuscript of larger format than a narrow palm leaf became all the rage. During the rule of the Lodi dynasty in Delhi in the fifteenth century, miniatures became a part of the court painting tradition. But it was only under the Mughal rule that the practice flourished extensively.

When Humayun was defeated by an Afghan chieftain Sher Shah Suri in 1539-40, he fled to Persia (modern-day Iran) and took refuge in his cousin's court. There he encountered the Persian miniature paintings that were used to illustrate Islamic manuscripts. When he returned to India in 1555, he brought with him two master miniature painters from Persia and thus laid the foundation of the strong Mughal miniature painting tradition in India.

After his death, his son and the most well known of the Mughal rulers, Akbar, created the royal studios in his new capital Fatehpur Sikri where exquisite illustrations were done on the manuscripts or leaves of the royal albums, all supervised by a master painter or ustad. Vivid, flat colours were used in these illustrations that were so painstakingly intricate that the brushes to colour these paintings were made using only a couple of hairs from a squirrel or camel's tail!

Over the next century or so, with the seeds of the Mughal style of art successfully sown, miniature paintings flourished as the reins of power passed from one emperor to the other—reaching its height during the rule of Jahangir. Earlier, teams of artists worked on the same miniature painting, but during this period, the artists

became specialists, such that some painted court scenes, some painted only animals, while some others were experts in painting portraits.

Since the miniature paintings developed under the patronage of Mughal rulers, portraits were the most popular. The miniature artists mostly created the profile portraits of the Mughal kings—they showed about three-fourths of the face, which is somewhat between the front and the side views, for the artists believed that this brought out the individual characters of the kings in the most effective manner.

Jahangir's son Shah Jahan kept the miniature tradition alive, but during the rule of his son Aurangzeb, who was not very encouraging of fine arts, the Mughal miniature tradition started weakening and eventually withered away.

Miniature paintings are marvellously detailed and bring alive the times they were created in. You can actually think of the Mughal miniature paintings as a pair of special binoculars that can help you peep into the Mughal Empire in all its glory—the lives of the kings and queens, their favourite pastimes, their lavish celebrations and gorgeous costumes and even their battles and conquests.

WHAT'S ALL THIS TO DO WITH BANI THANI?

When Aurangzeb rose to power, the Mughal miniature tradition started declining. He had great military prowess but lacked appreciation for fine arts. He disbanded the royal atelier, leaving the miniature artists jobless.

Many of these artists sought the patronage of the nearby Rajasthani royal courts. The Rajput kings

weren't as wealthy as the Mughal emperors, but many were admirers of art. They employed the miniature artists and thus saved the tradition from fading away. But since the artists were now under new kings, a new style began to develop that differed from the Mughal miniatures in terms of the use of bold colours and depiction of Hindu mythology. These paintings came to be known as Rajput miniatures.

Instead of royal albums, these paintings were done on loose sheets of paper or on the walls of havelis, and many Rajasthani princely states like Jaipur, Mewar, Malwa, Jodhpur, Kota, Bundi and Kishangarh became the major centres of the art form.

There developed a most charming centre of miniature painting in Kishangarh in Rajasthan that was known for its portraits. It is believed that this region was inherited by Kishan Singh, the eighth son of the king of Jodhpur, Raja Udai Singh, in 1609. And the place came to be known as Kishangarh in honour of its ruler. After Kishan Singh, many other rulers ascended the throne until Raja Sawant Singh took over the reins in 1747 and the art of Kishangarh reached its climax.

Raja Sawant Singh was an expert in music and painting. He was a scholar and a poet and was well-versed in Hindi, Sanskrit and Persian. He was a devotee of Lord Krishna and wrote devotional poetry. He was also very encouraging of artists and maintained a retinue of the very best writers, painters and musicians in his court.

There was this one master painter in his court that he was particularly fond of—Nihal Chand. He brilliantly executed various types of human figures with delicate

features and slender bodies. Even the landscapes that he painted—with broad vistas, rivers and streams, rows of overlapping trees and architecture—were much admired by the king. The chief attraction of the paintings that Nihal Chand created, however, was the depiction of women. In no other region in Rajasthan have the women been painted so beautifully—with long faces, sloping foreheads, pointed nose and bulging, well cut-out lips—as in the Kishangarh miniature paintings.

There's one set of paintings that has a special place among the Kishangarh miniatures—those of the elegant and super graceful Bani Thani. Created by Nihal Chand, these paintings show an elegant woman in profile, with an exaggerated lengthening of the eyes and nose and a subtle smile on her lips. It is believed that Nihal Chand was inspired by a series of poems that Raja Sawant Singh had written and translated the poetic passions of his master into a series of paintings based on the main subject of these poems—the beautiful Bani Thani whose smile is often compared to that of Mona Lisa.

The exact number of Bani Thani paintings created by Nihal Chand is unknown. He also trained other artists in the royal court as well as his sons in this style of portraiture and later Bani Thani became a standard of sorts for feminine beauty in the Kishangarh miniatures.

WHO WAS THIS LADY?

Legend has it that the real name of Bani Thani was Vishnupriya. She was a talented singer in the royal harem of Chandni Chowk in Delhi. In 1739, Raja Sawant Singh

brought her to Kishangarh as an attendant for his mother. But he became so enamoured by her beauty and singing that he fell in love with her and started worshipping her as Radha. Since Nagari is another name for Radha, he gave himself the pen name Nagari Das, under which he wrote many beautiful poems praising her beauty. Vishnupriya later became one of the wives of the raja (kings used to have several wives at that time).

Vishnupriya had a thing for fashion. She always wore exquisite gold and pearl jewellery, fancy make-up, fashionable clothes, henna on her palms and painted her fingernails. It is her impeccable fashion sense that set her apart and she gained the tag Bani Thani or someone who's always well-turned-out.

Raja Sawant Singh compared his love for Bani Thani to that of Radha and Krishna and he commissioned Nihal Chand, his most favourite painter, to interpret his poetry and create a series of paintings where Raja Sawant Singh was Krishna and Bani Thani was Radha. It is believed that the raja, who was himself an amateur painter, even gave the artist a rough sketch of how he wanted her to be portrayed. And so, Bani Thani became the face and form of the Radha drawn in the Radha-Krishna miniatures of that time.

The highly stylized features in these miniatures are quite distinct from any other female facial type in Rajasthani paintings. What's even more fascinating is that if you look at the Kishangarh paintings of this period closely, you'll find that even Krishna's face resembles that of Radha—suggesting that Krishna and Radha were actually mirror images of each other!

DID VISHNUPRIYA ACTUALLY LOOK LIKE BANI THANI?

Historians believe that while Bani Thani was indeed inspired by Vishnupriya, the woman in the paintings didn't quite look like her. The Bani Thani paintings actually portray an idealized form of beauty, influenced by ancient Indian sculptures, as conceived by the artist and his patron. The artist took cues from Radha's description in oral traditions and, infusing the side-profile portrait technique of Mughal miniatures with the rich colour palette of Rajput miniatures, created a highly stylized portrayal of an ideal female form.

If you look at a Bani Thani painting, you will see that certain facial features are quite exaggerated, like the elongated face, large lotus-shaped eyes, arched eyebrows with a sharp nose, the lips resting in a gentle pout and night-black hair cascading down her body in delicate curls. Bani Thani is dressed like Radha, too, in rich shades of bright colours, with traditional Rajasthani sheer *odhni* (or veil), adorned with gold and pearl beaded jewellery around her neck and on her head, ears and nose. These characteristics formed the basis of Kishangarh style paintings, and all the main female characters are in this tradition in the later paintings as well.

For its artist, Bani Thani might just have been a painting, but hundreds of years later, it has become one of the most compelling mysteries of the Indian art world! It has now become a larger-than-life tale, framed on the canvas by the able hands of Nihal Chand, even though she remains half-real, half-imaginary; half-Radha and half-Vishnupriya.

IS THE LOVE STORY AT LEAST TRUE?

That's one of the great mysteries of Rajput miniatures. There are people who believe it's true and that in the later years of his life, Raja Sawant Singh gave up his throne and went to Vrindavan where he lived with Vishnupriya, until they both died. Others say that it is only a legend and Bani Thani is just a fragment of the artist's imagination.

However, there are only a few details about the life and inspiration of the artist Nihal Chand and many have wondered just what inspired him to create this beautifully dressed lady who's standing calmly, with her body slightly away from the viewer. When you look at her painting, you can't really tell whether she's standing by a window or sitting on a throne. And what really is she thinking? Is she happy? Is she sad? We'll likely never know!

But despite all the guesswork surrounding these masterpieces—or perhaps because of it, the miniature paintings of Bani Thani keep her story alive.

BE AN ARTY-PANTS!

Picture Nihal Chand, the famous miniature artist, painting a live portrait of Bani Thani. Exercise your imagination and think of the entire scene: Where is this portrait session happening? Inside the painter's studio or in the royal gardens? What all is there in the background? How are Nihal Chand and Bani Thani dressed? Why is Bani Thani smiling secretly? Does she know a secret? Or is she remembering a humorous memory from her childhood? Or maybe the painter has something stuck in his teeth? Let your imagination run riot—your story can be as funny or serious as you like!

Now pick up a pencil and write it down. You can also give shape to your imagination through a drawing if you like.

WHO WAS THE REAL MANAKU OF GULER?

Time period: Late eighteenth century CE
Location: Kangra District, Himachal Pradesh

In the gallery of miniature paintings in National Museum, New Delhi, hangs the portrait of a painter at work—he can be seen sitting on the floor, wielding a thin paintbrush, all poised to give shape to his imagination on a piece of paper that is kept on his slightly raised knee. A little above his portrait is written 'Manaku Chitrakar', or Manaku the painter, in red ink.

It is one of the very few portraits found till date of Manaku, believed to be a master miniature painter who worked at the royal court of the small princely state of Guler in the eighteenth century. But here's the curious bit—each of his portraits is different from the other! The artist has left no signatures, titles, dates or comments on any of his works—giving out absolutely no clue to his identity, thereby throwing art historians into a tizzy and leaving them with an intriguing question: who was the real Manaku of Guler?

WHERE IS GULER?

On the foothills of the Himalayas, in the Kangra district of Himachal Pradesh is the small hill town of Guler. Surrounded by the snow-peaked mountains on one side

and the shining waters of the Ban Ganga on the other, Guler is really a blip on the screen of Indian art history.

At the turn of the eighteenth century, the Mughal ruler Aurangzeb was in power. Not very encouraging of the arts, he disbanded the royal studios in Delhi that consisted of some of the finest painters, calligraphers and papermakers who created works of art for the royalty.

Left with no work, many of the painters migrated back to the places they originally hailed from, primarily Rajasthan and lower Himalayas (present-day Jammu, Uttarakhand and Himachal Pradesh). With thick bundles of sketchbooks under their arms and squirrel-hair brushes and natural pigments in their bags, some of them knocked the doors of the regional courts in the Himalayan hills for patronage.

The rulers of the small kingdoms in the hills often lacked the resources of the mighty Mughals, but some of them were discerning patrons of the arts. When they started employing these artists who were trained in the Mughal studios, their courts suddenly teemed with creativity. Around this time, Guler became one of the important centres of Pahari (*pahar* is Hindi for 'hill') miniature paintings and many painter families settled there. One of these families of talented artists would bring historic changes to miniature paintings—that of Manaku.

WAS MANAKU ONE OF THE MIGRANT PAINTERS?

Manaku's father, Pandit Seu, was among the migrant artists who worked in the Delhi durbar and had imbibed the best of Mughal miniature painting style. Traditionally

from the carpenter-painter (tarkhan-chitere) clan, Pandit Seu was conferred the title 'pandit' because of the unusual artistic skill he possessed. ('Pandit' means someone who is supremely learned and skilled.) After the Mughal atelier in Delhi disbanded, the ruler of Guler, Raja Dilip Singh, gave shelter to Pandit Seu and he, along with his family, settled in the remote but beautiful town of Guler.

Pandit Seu had two sons—Manaku and Nainsukh. He initiated his sons into the world of painting at a very young age. He trained them in his small workshop in a style of art that showed familiarity with the Mughal style of miniature painting but was different in terms of the subject matter. Instead of the court scenes that were common subjects in the Mughal studios, he introduced them to subjects that interested the Raja of Guler, based on Hindu epics like the Ramayana and the Mahabharata.

The two brothers were quite different from each other, in terms of their artistic approach. While the younger and the better known of the two, Nainsukh, was innovative and bold in his approach, Manaku—who was older than Nainsukh by ten years—closely conformed to the style of their father.

When Nainsukh was in his late twenties, he left his father's workshop and moved to Jasrota, another small town in the hills, and started creating works for the king there. (We don't know why he moved. He may have wanted to travel or maybe he thought that Guler was too small to accommodate two painters of such great calibre as his brother and himself!)

Manaku stayed on in Guler and joined the royal court where he created a number of paintings. And, just like many other painters of that time, he remained unknown.

Manaku almost never signed his work and amongst the hundreds of works that are now accepted as created by him, his name appears as inscriptions on only four of them—and that too not in his own hand. In terms of documentary evidence, such as birth and death records, there is absolutely nothing available. It seems as if this great painter appeared, created some magnificent work, and then disappeared into the vast sea of anonymity!

HOW CAN WE BE SURE THEN THAT MANAKU REALLY DID EXIST?

Dr B.N. Goswamy is an art historian who turned into a sleuth to do some sharp detecting. In the late 1960s, he analysed the tiniest of clues and cracked the mystery of the little-known eighteenth-century artist.

For centuries, not much was known about the obscure Manaku and his younger brother Nainsukh. In his quest to bring to light the Pahari painters from the shadows of time, Dr Goswamy travelled across the Kangra hills and acquainted himself with the folklore, myths and the language of the region. Among the many painters whose works were discovered, he found the works of the brothers Nainsukh and Manaku absolutely phenomenal—but couldn't find much about them.

One day, when Dr Goswamy was feeling rather disappointed at not being able to gather much information on the Guler brothers, a childhood memory suddenly flashed in his mind. As a child, he'd visited Haridwar and had misspelled his name on one of the *bahi khatas,* or genealogical registers that the pandas or the priests

in Haridwar and other pilgrim centres keep. It is widely believed that every Hindu pilgrim finds a mention in the registers of these priests.

This incident got Dr Goswamy wondering if the Guler brothers had been pilgrims once—and if there might be some records of them in one of these registers. He decided to try his luck. Around the same time, he also chanced upon a painting by Nainsukh in which he could be seen accompanying the ashes of his patron, the king of Jasrota, to Haridwar. This firmed Dr Goswamy's resolve to visit all the pilgrim centres.

Dr Goswamy travelled across various holy cities such as Haridwar, Kurukshetra, Gaya and Varanasi. He combed through pages upon pages of the bahi khatas of the Guler region from the eighteenth century. It was a very complex task, for many people visit these places, the registers aren't properly kept and human memory can sometimes be notoriously unreliable. It took Dr Goswamy a *really* long time to leaf through each one of them.

Three years of painstaking detective work and piles and piles of registers later, Dr Goswamy did finally find the clue that he had long been looking for. He stumbled upon an eighteenth-century entry by—guess who!—Manaku in the register of a priest in Haridwar! The entry was just one-and-a-half lines written in Manaku's own hand. To most it might seem like nothing, but to Dr Goswamy it was pure gold. It said: *Manaku Tarkhan. Basi Guler ke. Betey Seu ke. Potey Hasnu ke. Sammat 1793.* (I, Manaku carpenter, resident of Guler, son of Seu, grandson of Hasnu, Year: 1793). There was also a tiny miniature painting, about

two inches in size, next to the entry that depicted Ganga descending to earth, drawn by the master painter himself!

WHAT HAPPENED AFTER THAT?

Dr Goswamy's breakthrough discovery formed the basis of his reimagining the life and times of the artist. Manaku was not an easy man to track and—apart from the wisps of information in the entry in the register—the only notes that he left behind were his paintings.

Dr Goswamy scoured museums around the world to find Manaku's lost work. He read them closely and moved back and forth between them to decode the time, themes and Manaku's trademark style.

How did he do that? Exactly how we look at an old family photo and try to locate it in time and place a context to it! 'When was this?', 'Where was this?' or 'Who's that in the background?' are some of the things that we find ourselves wondering while staring at an old black-and-white photograph, right? Art historians also work with similar questions: 'Whose portrait is this?', 'When was it painted?' or 'Are there patterns or similar things connecting two or more paintings?' They might look at other things too, like the style of clothes that people in the painting are wearing, or the everyday objects in the painting, to find out the exact time when it was painted and also about the artists who crafted it. So, whether it is an old family photo that you discover in your attic or a long-lost painting that a historian unearths from a forgotten site, looking at it closely can be a powerful lens into the past.

Dr Goswamy, too, used this powerful lens to gather information about Manaku and put together some of the pieces of this complex jigsaw puzzle.

DO MANAKU'S WORKS TELL US SOMETHING ABOUT HIM?

With his soaring imagination and great skill, Manaku gave a different direction to the tradition of miniature paintings.

He had an amazing grasp of the epics and mythological narratives and painted themes that had not been illustrated before. He also possessed the genius to give form to abstract concepts such as time and space and, within the pre-existing form of the miniature painting, he found his own originality. Unlike Nainsukh, he had little interest in portraiture and court scenes; he drew mostly from mythology—and while Nainsukh had a light, witty take on his subjects, Manaku was more philosophical and introspective.

Manaku might be a well-kept secret as his name suggests (Manaku means 'ruby', the stone of mystique), but he had a lot to offer. He is documented to have worked on at least three incredible series of paintings—*Siege of Lanka, Gita Govinda* and the *Bhagavat Purana*.

Siege of Lanka is a set of illustrations that he created based on the last part of the Ramayana, taking it forward from the point where his father, Pandit Seu, had left it.

He also painted over 150 paintings based on the twelfth-century Sanskrit poems of *Geet Govind* by the poet

Jaidev. No illustrations on this theme had been painted in the Pahari region before. Without any reference or precedent to follow, Manaku gave stunning visual form to the complicated text. One of the works created for this series carries a colophon (like an emblem or a logo), which says that the work was commissioned by Malini, but no one knows who Malini was.

The third series that Manaku painted extensively was stories from the *Bhagavata Purana*. The latter works in the series, however, show a complete change in painting style as compared to the earlier ones. Curiously, many unfinished sketches and preliminary drawings of a set of paintings have also been ascribed to Manaku. Why didn't he complete these sketches or take these painting projects to fruition? Well, no one knows.

BACK TO THE BIG QUESTION: WHO WAS THE REAL MANAKU?

Because of the effort and imagination of historians like Dr Goswamy, we now know a little about Manaku. But there's still a lot about him that we do not know. Which of his portraits is closest to how Manaku really looked? What led to the stylistic changes in his work? What misfortune led him to not complete some of the projects he'd started? Who was his primary patron? Was Malini his patron princess or some kind of a metaphor? What were the thoughts of this master painter who lived in a tiny Himalayan state? No one has been able to find the answers to these questions thus far.

All mysteries have clues somewhere. They may be hidden in forgotten places or in the faded memories of someone or in secret symbols that need to be deciphered. But old codes can be broken and lost treasures can be dug up—what's needed, though, is to follow one's curiosity. Who knows, maybe one day you can help unravel the mystery of Manaku that the historians around the world have been fussing over!

BE AN ARTY-PANTS!

Many generations of artists have been inspired by stories and poems from the past and have drawn upon them to create art. Do you have a favourite story or poem? How about illustrating a scene from it as a miniature painting?

Take a sheet of paper and make a quarter-inch border around the edge of it. Visualize the scene that you've chosen from the story or poem and sketch it. There are usually a lot of details in miniature paintings—so create characters and things that relate to the scene in the story. Give special emphasis on the natural surroundings in the scene, and the clothing of the characters. Use vibrant colours to colour your painting. And, yes, don't forget to put dates and titles and signatures and comments to your masterpiece, so you don't end up befuddling art experts many, many centuries later!

WHO PULLED OFF THE BIGGEST ART HEIST?

Time period: 2006 CE
Location: Sripuranthan, Tamil Nadu

It is an evening like any other in the village of Sripuranthan in central Tamil Nadu. The dusk is descending slowly as the orange sun is being swallowed bit by bit by the thick coconut trees near the ancient Brihadeesvarar Temple in the heart of the village. Upon hearing the distant rumble of the temple priest's motorbike, the young caretaker of the temple opens the temple's creaking iron gate.

About a minute later, the temple priest, wearing a saffron *veshti* and a sacred thread around his chest, arrives. He parks his motorbike and gets down from it. As he enters the temple, he chants Lord Shiva's name thrice and pours a little water over his head.

It's dark inside the temple. The priest switches on a bulb and the yellow light fills the nooks and crannies of the giant, old stone temple, exposing its beams and columns that are textured by time and mould. Some bats fly overhead, shrieking at the impolite intrusion. The priest stands nonchalantly—for him, it's an everyday thing.

He lights the traditional brass lamp and makes his way towards the seat of the main deity of the temple. He places the lit lamp at a bare altar and offers his prayers to an

empty spot! For the thousand-year-old bronze sculpture of Shiva Nataraja has been missing from his abode for over a decade, making the Brihadeesvarar Temple in Sripuranthan a temple without a god.

But where did the fine specimen of ancient art go?

WHAT'S THE STORY BEHIND THIS OLD TEMPLE?

In 985 CE, one of the greatest kings of southern India ascended to the throne—the king of kings, Rajaraja Chola I. From his power base in the Cauvery delta region in central Tamil Nadu, his kingdom extended to Sri Lanka—which remained under the Chola Empire for seventy-five long years—the islands of Maldives and even Sumatra. An able administrator and a great lover of architecture, Rajaraja Chola I was very encouraging of the various arts and his reign (985–1014 CE) came to be regarded as one of the most creative periods of Tamil culture.

Rajaraja Chola I was an ardent devotee of Lord Shiva and a wide-ranging Shiva iconography evolved during his time—one of them being the bronze sculptures of the dancing figure of Shiva Nataraja (meaning 'the lord of cosmic dance'). Artists created these images in beeswax and then casted them in bronze—the ancient metal casting technology known as the lost wax process. Measuring from one foot to six feet and weighing between a few grams to a few hundred kilograms, these beautiful sculptures were richly adorned with jewellery, silks and flowers and carried in processions during festivals.

Many magnificent temples dedicated to Lord Shiva were also constructed along the banks of River Cauvery during his reign. It is believed that over the height of Chola power in southern India, at least 300 stone temples were built, which are considered some of the finest examples of architectural achievements for their grand conception, artistic prowess and powerful sculptures. One such temple is the Brihadeesvarar Temple in Sripuranthan (not to be confused with the famous Tanjore temple of the same name).

For the longest time, the residents of the village of Sripuranthan thronged the thousand-year-old temple to offer their prayers on festivals and special occasions. But in the mid-1970s, the state government took over the administration of the temple. The temple priest, not too happy with his meagre salary, decided to leave for Chennai. Before leaving, he locked the wooden gate to the main temple.

A few years later, a rumour too began to spread that there was a hive of deadly killer bees inside the main temple, deterring the people of the village from opening the wooden door and paying a visit to the gods—which included Lord Ganesha, Saint Sampanthar, Goddess Sivagami and, the finest of all, the bronze Shiva Nataraja. Over a period of time, people abandoned the temple and its tumbled ruins became a refuge for bats . . .

After over three decades of abandonment, in 2008, some officers from the Hindu Religious and Charitable Endowments (HR&CE) department, one of the departments of the state government that looks after the administration of various temples in the state, showed

up in Sripuranthan. They suggested shifting the temple idols to a dedicated idol centre for their safekeeping. Like many Chola sculptures, the idols in this temple were very valuable because of their metal content and age. The residents of the village, however, were reluctant to hand over their gods, so they promised to replace the wooden gate with an iron one to secure the idols.

Less than two months later, the iron gate was delivered. The people of the village and the officers of the HR&CE department gathered to break open the old wooden gate and affix the iron gate. But, as they made their way through the foliage that enwrapped the temple, they saw that the lock was already broken! They pushed open the wooden gate to find that there were no killer bees, only small bats. And then they saw the unbelievable—most of the idols, including the Shiva Nataraja, were missing. The gods had been STOLEN!

HOW DID THAT HAPPEN?

There were no witnesses (or none that came forward) to the loot of the temple and so, no one knows how a three-foot-tall bronze Shiva Nataraja statue that weighed 150 kilogram was stolen from the temple. The investigating agencies, however, after a lot of spadework and help from some art enthusiasts, found some evidence that the loot was orchestrated by an international art dealer and was carried out by a gang of notorious temple thieves.

This is what the investigators believed happened: Subhash Kapoor, an India-born New York-based art dealer and owner of an antique art gallery, was on a

lookout for the most prized Indian artefacts (things of historical interest that you find in museums) to sell in the international market. He got in touch with a local art dealer in Chennai, a man named Sanjeevi Asokan, who knew a lot about ancient temples and the sculptures in them. Asokan told Kapoor about the antique metal idols of the Chola Empire in the old, dilapidated and little-known Brihadeesvarar Temple in Sripuranthan. Kapoor was sure that the temple sculptures would fetch him big money in the international market and so, along with Asokan, he hatched a plot to plunder the ancient temple.

They recruited a gang of seven local, small-time temple robbers who went in small batches to Sripuranthan for a recce and found out, much to their delight, that the temple was locked and crumbling, and no villager ever visited it. Like all good planners, the robbers kept things simple and prepared carefully. They had discovered, for example, that on one side of the temple was the wide bed of a dried-up lake, far from the village—so they decided to approach the temple from there so that the villagers couldn't catch even the slightest whiff of what was happening.

In January 2006, the seven of them sneaked into Sripuranthan one dark night in a lorry. They skidded the lorry to a stop on the dried-up lake bed and walked to the temple. They pulled at the lock of the temple's wooden door and, because the lock was old and rusted, it came unstuck quite easily. The robbers quickly removed the idols, glued the lock back together with an adhesive, loaded the idols into their lorry and drove away.

Meanwhile, Asokan had got some replicas of the sculptures made. He mingled the original antiques with

the fakes in a container and shipped it from Chennai via Hong Kong and London to Kapoor in New York.

The theft, of course, wasn't discovered for years. And by the time it did, it was too late—the Shiva Nataraj had reached the other side of the globe!

HOW WAS THE PLOT EXPOSED?

When the investigating agencies got to know about the missing statue, they asked the residents of the village for the photographs of the idols that were stolen from the temple, but there were none. Photographing gods was considered a bad omen. The villagers had stopped going to the temple years ago, so public memory was not a reliable source of information. The agencies also had no clue about when the theft had taken place since nobody had reported it. So, after some months of rigorous investigation, the investigation agencies reached a dead-end and the case went cold.

But the thing about art robberies is that the robbers need to sell their loot in order to make money. So, there are high chances of the stolen piece of art resurfacing in art auctions or in galleries and museums around the world. This is exactly what happened in this case as well.

Some four years after the temple robbery, Subhash Kapoor put up photographs of Shiva Nataraj and Goddess Sivagami on one of his gallery catalogues. It was seen by an art enthusiast called Vijay Kumar in 2010.

An officer in a shipping company in Singapore, Kumar was an antiquities buff who loved to flip through museum

catalogues and photos in his spare time, and had special interest in Chola art. One night, as he was browsing through some online museum catalogues, he came across the photographs of Shiva Nataraja and Goddess Sivagami in the catalogue of Kapoor's art gallery. The photographs showed that the idols were in impeccable condition and, quite rare for bronze idols, had an inscription on their base pedestals. The sculptures stunned Kumar with their beauty, but they also left him with a lingering suspicion—the inscription on the pedestal appeared to be a Chola one to him.

There was also something about the colour of these sculptures—they appeared to have been worshipped for a long time, for there were residual remains of what seemed like oil on them. This got Kumar's antennae twitching. He wondered if the idols had been fairly recently removed from a Chola temple in India and if so, then which one. He looked through various books and art gazettes, page after page, volume upon volume, but to no avail. But Kumar didn't give up and continued undeterred.

Finally, his hard work bore fruit. There was indeed one record of the idol: in the archives of the French Institute of Pondicherry (IFP) in Puducherry. They had been documenting temple sites in Tamil Nadu since 1955 and their scholars had photographed the Brihadeesvarar Temple in Sripuranthan during various field visits. The archival photographs of the idol matched with the ones in the catalogue of Kapoor's art gallery and the dots linking this to the temple robbery emerged clearly.

Kumar got in touch with the law-enforcement agencies and supplied them with the proof. They, in turn, contacted

US authorities. The US authorities raided Kapoor's warehouse. They discovered stolen Indian artefacts worth $100 million (some Rs 700 crores in today's worth!), which led to the dramatic arrest of Subhash Kapoor in 2011. But the Shiva Nataraj wasn't one of the recovered artefacts!

WHERE WAS THE SCUPLTURE OF SHIVA NATARAJ?

By the time the culprits were arrested, the Sripuranthan Shiva Nataraja had already been sold by Kapoor to the National Gallery of Australia (NGA) in Canberra for a whopping $5.1 million (around Rs 40 crore now)! Before selling the sculpture to NGA, he had removed the pedestal of the idol, and also changed the colour of the idol, so as to make it difficult for the investigators to ascertain that it was the Shiva Nataraja from Sripuranthan.

During the investigation, however, the archival photographs from IFP were compared with the photographs of the idol in the NGA and seven features matched. On establishment of identification, the Indian government wrote to the Australian government, which led to the NGA removing the Shiva Nataraja from display. And then, in September 2014, the Australian government returned the thousand-year-old Shiva Nataraja idol to India, with then Prime Minister Tony Abbott handing over the idol to India.

And so, the mystery of the Shiva Nataraja was put to rest. Kapoor is still being tried for the theft of several antiques, including the Sripuranthan Shiva Nataraj and his suspected links with a larger smuggling racket. So, the full details of

this most audacious art theft have not been fully revealed. We are also yet to fully know the true scale of his other loot.

But this important piece of Chola history came back to India, and the people of the village of Sripuranthan were exhilarated. They repaired the temple and decorated it. The sounds of the nadaswaram and the rhythmic beats of drums filled the air as the people of the village prepared to welcome their god.

But that was not to be! The HR&CE department decided to keep the idol at the government museum in Kumbakonam to ensure its safety.

Once every year, amidst tight security, the Shiva Nataraja makes a journey to his native village during the Arudhra festival and bestows blessings upon his devotees. On the other days of the year, the Nataraja rests in a glass case in the government museum while the people of the village of Sripuranthan pray to an empty spot . . .

BE AN ARTY-PANTS!

Look up some images of the Chola bronze sculptures of Lord Shiva Nataraja on the internet. Observe them carefully.

Try imitating Shiva Nataraja's pose. How does this pose feel? Fearless? Joyful? Scared? Why does the Nataraja pose make you feel what it does? (Think hand gestures, powerful stance, facial expressions, etc.) Imagine what happens next—if Shiva Nataraja could come to life, how would his body move?

Now take a piece of paper and draw Shiva Nataraja on it. You can also colour it if you like!

Mamta Nainy is a writer based in New Delhi. She has authored over thirty books for children, including *A Brush with Indian Art* that won The Hindu Young World-Goodbooks Award 2019 and *Mutthasi's Missing Teeth* that won the Peek-a-Book Children's Choice Award 2019. She also works as a literary translator, translating primarily from English to Hindi, with several published works of translations. Mamta loves clambering around old caves, exploring lesser-known monuments and spending time in museums. Her favourite place to be, however, is in the middle of a book.